NEW YORK SLEEPS
CHRISTOPHER THOMAS

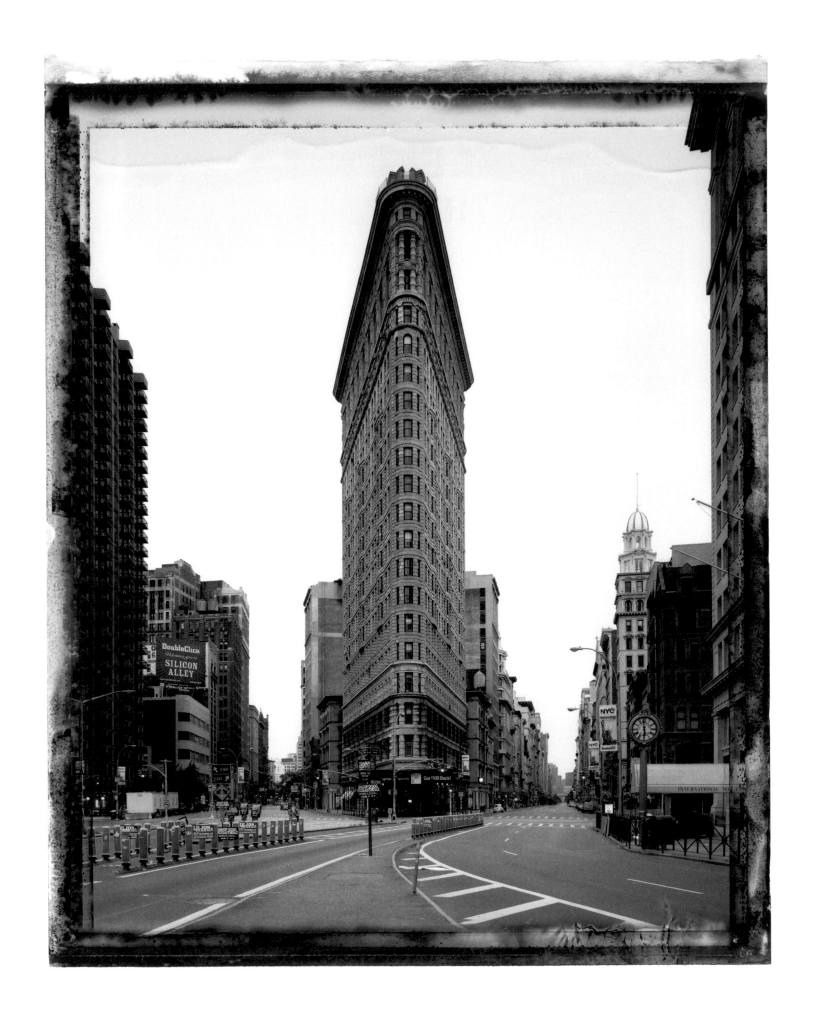

NEW YORK SLEEPS
CHRISTOPHER THOMAS

EDITED BY PETRA GILOY-HIRTZ AND IRA STEHMANN
WITH ESSAYS BY ULRICH POHLMANN AND BOB SHAMIS

PRESTEL

MUNICH · BERLIN · LONDON · NEW YORK

For Lucy

CONTENTS

NEW YORK SLEEPS

FOREWORD BY PETRA GILOY-HIRTZ AND IRA STEHMANN

This is New York! Or are they dream worlds, chimeras, inventions, or perhaps testimony to a past era? Viewers are astonished, recognizing the places and getting lost in memories. A city of silence, beyond the turbulence of everyday life, a metropolis with no people, as if a spell had been cast on it: Grand Central Station, Fifth Avenue, the Flatiron Building, Katz's Restaurant, the Brooklyn Bridge — familiar, but never seen this way before.

When we unsuspectingly removed these photographs from a drawer in his studio — seven views, all taken in 2001 (before September 11), softly sketched as a result of long exposure times, printed on deckle-edge paper with the streaky border of a Polaroid—we urged the photographer to return to New York, where he had lived now and again over an extended period, in order to continue the series. Over two more years, including stays in each of the seasons, he produced a portfolio of photographs, of which the present volume presents a selection of nearly eighty works.

With his clear idea of shooting techniques, composition, light, formats, and his dispensing with color, the exquisite printing in rich, subtle tonality, and the form of the images' presentation — handmade paper, passe-partout, frame — Christopher Thomas picks up on classical traditions. As a renowned photographer of a glamorous world of products, he has access to all advanced technological possibilities. However, as an artist, he places his faith in the power of the image. His photographs seem classical, from another time.

Before dawn, when the city is asleep, Thomas sets out in the twilight with his large-format camera — a field camera built for him by Linhof — which forces him to move slowly, as well as a tripod, a black cloth, and black-and-white Polaroid film. It is as if he were taking himself outside of time. As if, at this moment when night borders day, he could uncover the essence of the city, erasing the profane and quotidian in favor of the "eternal" or timeless. He approaches his motif with a documentary intention and at the same time establishes the aesthetic of the painterly Romantic. He concentrates on the real, focuses attention on the object, and yet a hint of "another" world becomes tangible. Like idealized landscapes in the Romantic tradition, his photographs have a poetic sensuality, contemplative power, and an emotional aura; they evoke sensations such as admiration, delight, aesthetic pleasure: the parks and piers, the Hudson River and Coney Island, the cemeteries and bridges, the Statue of Liberty, in the early morning fog, beneath autumn leaves, schemas in the mists, pristine blankets of snow, silvery skies, gleaming surfaces of water, squares, and monuments — all without any traces of *flaneurs* or residents.

Hidden away in the beauty that derives from silence are melancholy and fear of loss. The perfect always bears its own inherent risk, and the stasis of time includes change. What may nostalgically seduce our eyes as a "souvenir," a memory, also evokes as an alternative vision the racing speed, the inhumane, and the wounds of the city.

We are very pleased that two outstanding connoisseurs of classical and contemporary photography have written essays for this publication: Ulrich Pohlmann, who has been director of the Fotomuseum München for many years where he exhibited Christopher Thomas' cycle *Münchner Elegien* (Munich Elegies) in 2005, and Bob Shamis, himself a photographer as well as curator for photography, for many years at the Museum of the City of New York. Bob Shamis offers "an impressionistic discussion" of Christopher Thomas' work, and, having looked at thousands of photographs of New York, he appreciates their uniqueness. Pohlmann outlines Thomas' "European view," his romantic (re)construction of the City," and his "homage to the beauty of urban architecture" in the context of historical connections. Quoting sources that range from Edward Steichen, Alfred Stieglitz, and Alvin Langdon Coburn — all members of the Photo Secession, founded in New York in 1902 — to contemporaries such as Helen Levitt, Inge Morath, William Klein, and Robert Frank, he has written a brief history of the photography of New York, which has also turned into a history of the city, its architecture, and the mentality of artists, opening our eyes for *New York Sleeps*.

It is fortunate that the publication of the book coincides with the public presentation of the photographs themselves: in New York, they are being shown by Steven Kasher in his new gallery spaces in Chelsea, and Blanca Bernheimer, Bernheimer Fine Art Photography, is showing them in Munich in the Palais at Brienner Strasse 7.

We are sincerely grateful to Prestel Publishing, which has produced a spectacular book, especially to Gabriele Ebbecke, Cilly Klotz, and Christine Gross for the project management, graphic design, and production management, respectively.

We thank Christopher Thomas with deepest appreciation for taking us on this adventure!

"THE PAST JOSTLES THE PRESENT"
ON THE TRAIL OF "OLD" NEW YORK: PHOTOGRAPHS BY CHRISTOPHER THOMAS
ULRICH POHLMANN

As a photographer, Christopher Thomas is truly at home in the world of advertising. His campaigns have received international awards and his portraits of celebrities have been published frequently in journals and illustrated magazines. As an alternative to such commissioned works, which usually have to satisfy the guidelines and expectations of his clients, the photographer began to shoot views of cities on his own initiative in order to — as he puts it — "get back to the roots." This effort to move his professional activity away from any commercial considerations and ground it in fundamentals inspired him first of all to capture the architecture in his native city, Munich. Later he set up his camera in New York. For this long-term project on an American metropolis, which he has been pursuing with great passion since 2001, he has been able to chose subjects, pick points of view, and follow his own plan and schedule at his own discretion, independently of others' wishes.

Like a *flaneur,* he has opened up the public spaces of this city, first roaming its neighborhoods on a bicycle like an urban archaeologist on the trail of the peculiarities and relicts of an "Old New York" that has long since become a myth. And, on his excursions, he often found just this, capturing surprising views of places that many New Yorkers scarcely notice anymore or that are at risk of disappearing from the cityscape altogether.

Christopher Thomas used a large-format camera for his long-term projects. His choice of this cumbersome camera and lenses can be seen as the expression or symbol of his contemplative approach, even of his meditative occupation with his theme. Unlike the "street photographer," who is equipped with a 35 mm camera and is highly mobile, always searching for spontaneous scenes amid the dynamic activity on the street, a large-format camera requires long exposure times and careful selection of a viewpoint. This reflective approach and slow work process can be interpreted as the photographer's deliberate attempt to decelerate the world, indeed to bring it to a standstill. Not only the more leisurely Munich but also a turbulent metropolis like New York seems to hold its breath in his images; hectic activity is transformed into metaphysical emptiness. The lack of passers-by who usually populate the city means that our perception is no longer distracted but concentrated instead on the city's "casing": its architecture and streets. This transformation of lively urban zones is particularly evident in Christopher Thomas' photographs of Times Square. The long exposure times erase the constantly changing lights of the advertisements, and this mecca of commerce can be perceived without external stimuli, with high precision and resolution. Much the same is true of the shots of Grand Central Terminal, which was the largest train station in the world when it was completed in 1913, though over time it has become less and less significant as transportation systems have changed, or those of Columbus Circle, once an important junction, with a sculpture of the discoverer of America placed at its center in 1892.

The cityscape is further abstracted by the artist's exclusive use of black-and-white photographs in the classical manner. The all but untamable color of urban life is left out of these panoramic views; every cacophonic element seems domesticated, and the city is reduced to the essential elements of its architecture. This concentrated vision is a special quality of Thomas' photography.

Naturally, this view of New York is also a romantic (re)construction of a city that has been constantly changing over the past centuries. Entire districts of the city have been demolished and rebuilt. In this way, older buildings have given way to taller and more modern skyscrapers; other significant buildings among the city's landmarks are at risk of disappearing in the continual rage of renovation projects in the metropolis.

Thomas' photographs of New York constitute a homage to the beauty of a city's architecture, whose quality and uniqueness is often overlooked by residents and visitors alike amid the frenzied hustle and bustle. Seeing his photographs, the viewer comes to rest and escapes the relentless dynamics of a cosmopolitan city, the everyday life of which is marked by the usual factors of traffic, noise, stress, and an excess of energy. Certainly his is a European view, shaped by the penchants for the traditions and experiences of the "old" continent. The echo of European architecture, for example, is felt in many buildings in the so-called Victorian style,

such as the neo-Gothic ecclesiastical buildings Trinity Church (built in 1846) and Grace Church, as well as the secular Plaza Hotel. The bold iron constructions of Brooklyn Bridge and Manhattan Bridge, which span the East River, also recall predecessors of nineteenth-century European engineering. The buildings of the decades between the two World Wars fall into another category. Among these city landmarks are the Guggenheim Museum, founded in 1939, and buildings such as Radio City Hall or another art deco jewel, an elegant symphony of steel and glass, the Cheyenne Diner, which only recently went out of business. One zone of rest and relaxation, by contrast, is Central Park, whose grounds, with its lakes, fountains, and romantic bridges, were laid out in 1859.

The skyscrapers — modern cathedrals of capital and symbols of economic prosperity — play only a secondary role in the image of the city that Thomas offers on view. The exceptions are older high-rises such as the Flatiron Building, built in 1902. Art photographers before the First World War had already been inspired to spectacular compositions by this building. Edward Steichen, Alfred Stieglitz, Alvin Langdon Coburn, and Karl Struss all photographed this high-rise, which was highly controversial in its day because of its unusual form; Sadakichi Hartmann characterized its architecture as follows: "It is a curiosity of modern architecture, solely built for utilitarian purposes, and at the same time a masterpiece of iron construction. It is a building without a main façade, resembling more than anything else the prow of a giant man-of-war. And we would not be astonished in the least, if the whole triangular block would suddenly begin to move northward through the crowd of pedestrians and traffic of our two leading thoroughfares, which would break like the waves of the ocean on the huge prow-like angle."[1] Beneath the gaze of symbolist art photography, even skyscrapers were transformed into mysterious emblems of a big city, which, from the dynamic of life, offers an image of calm and shows passers-by only as fleeting silhouettes. The Pictorialists preferred night or dawn and dusk; in twilight the city remains muffled in a cocoon and seems to be about to pupate silently. The daily life of the metropolis, by contrast, was observed from a genteel distance and with a dandy-like attitude. Artists remained reserved with respect to the materialistically influenced philosophy of life in the city, which was the most important economic and business center in the world. Steichen, Stieglitz, Coburn, and Struss — all members of the Photo Secession, founded in New York in 1902 — represented a new type of photographer who traveled the continents as urbane cosmopolitans and whose view of life was enduringly marked by their view of life in the big cities of Europe.

Art photographers who saw the metropolis of New York as a spherical likeness of mysterious squares and monuments differed fundamentally from photographers who represented the artistic avant-garde of the 1920s and '30s. The difference is exemplified in László Moholy-Nagy's book *Painting, Photography, Film*. The Hungarian Bauhaus master contrasted the "unbridled," modern perspectives of the New Vision with a painterly shot of New York by Alfred Stieglitz depicting the rain-soaked sidewalk on a busy street. At this time, atmospheric depictions of New York were considered mere escapism, "a denial of modern urban life."[2] This judgment was aimed primarily at the aesthetic approaches of art photographers, who liked to employ soft-focus lenses and prints using such high-quality techniques such as gum-and-platinum prints to create impressionistic images. This contrasted with the visual idiom of the New Vision, with its puristic depiction of forms and its realism intent on objectivity, clarity, and transparency.

Between 1920 and 1940 in particular, New York experienced a considerable construction boom. Skyscrapers shot out of the ground like mushrooms, and unlike in Paris or Berlin, radiated a dynamic sense of life that was all but unknown previously and with which no European metropolis could compete. During this phase of upheaval, which was also marked by the stock market crash and the Depression, many photographers showed a special passion for photographing this city. This generation of photographers, dominated by emigrants, included Paul Strand, D. J. Ruzicka, Mario Bucovich, Josef Breitenbach, and Andreas Feininger, and produced such impressive publications as *Manhattan Magic* (1937) and later *The Face of New York* (1954). However,

towering over them all, was Berenice Abbott who produced the most ambitious project on the cityscape of New York. Abbott too had become familiar with European culture having spent several years in Paris. After working as Man Ray's assistant, she successfully ran her own portrait studio. Eugène Atget's work had made a lasting impression on her, even before the Surrealists discovered his magical photos of Paris. After Atget died, Abbott purchased several thousand glass negatives and prints from his archive, later selling them to the Museum of Modern Art and thus preserving them for posterity. Atget is still one of the most influential representatives of documentary photography, and the special fascination and quality of the medium is unmistakably demonstrated in his work. Atget's precise photographs of deserted streets, of the façades of houses and store windows, reflect the modern experience of the big city as a "salutary estrangement between man and his surroundings," as Walter Benjamin described it. "Atget looks for what has gone unnoticed, forgotten …," Benjamin continued, "and his photographs pump the aura out of reality like water from a sinking ship."[3] Atget's photos are often quite unassuming views of Paris, but realism and the history and presence of the place are inscribed in them. At the same time, because the motif is isolated and removed from its context, they leave the viewer with a strange feeling that shifts between familiarity and unfamiliarity.

Then as now — and independent of their reception by the Surrealists — Atget's photographs have been highly esteemed by conservationists, architects, and craftspeople for their unusual quality. They are considered documents of "Old Paris" from the Belle Époque, which can no longer be seen in this state. Berenice Abbott pursued similar goals in her ambitious cycle *Changing New York*. She asked herself how she could depict the connection between "the flux of activity in the metropolis, the interaction of human beings and solid architectural construction, all impinging upon each other in time." It was of crucial importance to her to produce an organic unity between New York's famous landmarks and less striking buildings in order to unite the old with the new or to document the point of intersection where, in her words, "the past jostles the present."[4]

Photography is *par excellence* predestined to record the ephemeral and counteract the fading of memories. In its function as an archival store, it conserves the physical appearance of objects, people, landscapes, and buildings that are subject to change over time. One of the places steeped in history that Christopher Thomas sought out was Ellis Island, where the immigration authority was once located: an assembly point for millions of immigrants from overseas and now a museum for the history of immigration to the United States. Looking at the photographs of Ellis Island it is difficult to escape the effect of the human dramas that were played out here.

Naturally, the Statue of Liberty is not missing from his repertoire of "Old New York"; a gift from France to the United States in 1876, it is the symbol of a better life in the free world, though access to it has been restricted since 9/11. The docks and piers of the Rockaways in Queens are relics of a glorious past. Located on a peninsula on Long Island, it is difficult to imagine a starker contrast between this once vibrant center of trade and today's abandoned buildings and facilities.

Another melancholic swansong to past greatness and better times that will probably not return anytime soon is found in Thomas' photographs of Coney Island and its amusement park, which — much like Munich's "Oktoberfest" — attracts crowds with booths, daredevil roller coasters, and other spectacular attractions. With its long beaches, Coney Island was for decades a meeting place for millions of residents of the city. Today it stands for an entertainment industry in bankruptcy, largely closed down, hoping — probably in vain — for its resurrection.

Although Thomas pursued his project largely independently of his famous predecessors, there are occasional references or reminiscences of famous motifs. A homage to the photographer of "naked New York," WeeGee (Arthur Fellig), who became famous for his photographs of crime scenes at night, of victims and perpetrators, is found in the photographs of a gun shop on Grand Street, whose larger-than-life revolver Thomas photographed in broad daylight, much as Andreas Feininger did.

This metropolis and its architecture have attracted many photographers and inspired them to outstanding shots. Some, like Jacob Riis and the Brown Brothers, captured the dark sides of the American Dream with impressive photojournalism. Most, however, glorified the city's splendor. The number of illustrated volumes on New York published to date is too large to summarise. Helen Levitt, Evelyn Hofer, Francis Hidalgo, Reinhard Wolf, Inge Morath, William Klein, Robert Frank, and Thomas Hoepker, to name just a few representative names and distinct approaches, have all immortalized their personal view of the American metropolis in books. Christopher Thomas can easily and impressively stand his ground in this gallery of important contemporary photographers. Looking at his photographs, one can dream back to the past of a city whose architectural legacy will perhaps one day become an irredeemable part of a "lost New York."[5]

NOTES

1. Sidney Allan (aka Sadakichi Hartmann), "The Flat-Iron Building: An Esthetical Dissertation," in *Camera Work*, no. 4, October 1903, p. 36, cited in Dennis Longwell, *Edward Steichen: The Master Prints, 1895–1914; The Symbolist Period*, Museum of Modern Art, New York 1978, p. 134.
2. Bonnie Yochelson, "Introduction," in *Berenice Abbott: Changing New York*, Museum of the City of New York, New York 1997, p. 11.
3. Walter Benjamin, "A Little History of Photography," trans. Edmund Jephcott and Kingsley Shorter, in idem, *Selected Writings*, vol. 2 (1927–34), ed. Michael W. Jennings, Howard Eiland, and Gary Smith, Cambridge, MA 1999, pp. 518, 519.
4. Berenice Abbott, cited in Yochelson, (see note 2), p. 1.
5. Cf. Nathan Silver, *Lost New York*, Boston 1967.

COMING UPON NEW YORK

BOB SHAMIS

The New York images of contemporary German photographer Christopher Thomas seem to have very little precedent as a response to this crowded, intense, and often frenetic city, but his attraction to New York as subject is nothing new for a foreign photographer. Throughout the last century, New York City, with its patchwork amalgam of ethnic neighborhoods and as the symbol of American power, wealth, and culture, has been an irresistible subject and challenge for photographers from all over the world. However, its allure for photographers dates back much further, to the days when the medium was still in its infancy. In 1853 the French artist and photographer Victor Prevost opened a photography studio in Manhattan, on Broadway near Bleecker Street. He soon began to explore and photograph his adopted city, and over the next few years created the first known group of photographs that attempted to capture the city's urban landscape.

Prevost was to be the first of many Europeans to make significant contributions to the photographic record and imagery of the city. The list includes such notables as E. O. Hoppé, John Gutmann, Lisette Model, Henri Cartier-Bresson, Ernst Haas, André Kertész, and Thomas Struth. Confronting the vastness of New York, the city's mythology, and their own expectations, these photographers were able to put their unfamiliarity to advantage and use their fresh eyes to portray the commonplace from an unexpected perspective and to pay attention to what might go unnoticed by most New Yorkers.

Traveling back and forth between Munich and New York, Christopher Thomas began photographing this series in 2001, but made most of his images over the past two years. The photographer, who now calls New York his "second hometown," was first drawn to the major landmarks of the city, but his eye soon became more democratic—attracted to the outer boroughs, the city's mostly forgotten waterfront, and his own personal landmarks. Although the images range over a great deal of the geography of New York, the body of work Thomas produced is much too idiosyncratic and unsystematic to be anyone's guide to the city. Yet his images are extremely cohesive in their look and emotional tone.

Whether photographing the monolithic U. N. Secretariat, a pastoral scene in Central Park, or a Carvel shop in central Brooklyn, all of Thomas' images could be a record of the monuments and ruins of a long dead civilization. Preserved and uninhabited, the buildings and cityscapes in these photographs comprise an archeology of the present. The images in *New York Sleeps* resonate more with the views of the remnants of ancient civilizations by nineteenth-century photographers like Félix Teynard and Francis Frith in Egypt and Linnaeus Tripe in India than with the work of most contemporary urban photographers. They express the twin urges of nineteenth-century photographers to describe the material and particular—and at the same time—evoke the mysterious. We sense Thomas searching the streets and architecture of New York for some evidence or code to help him decipher what this civilization is about— to reveal what archeologists seek in the monuments and ruins of earlier civilizations, that is, not only a record of the material existence of extinct societies, but manifestations of a culture's values and beliefs. The result is the depiction of a city with the appearance of the present and the feel of a city from a past that has not yet occurred.

Thomas explored and recorded the city with the openness of an artist and the curiosity of a scientist. His images do not seem to contain or imply judgment, just fascination with the multiplicity of expressions of this hybrid culture. Consequently, he gives equal weight to the Cheyenne Diner and the Flatiron Building, to a snack stand in Coney Island and the Chrysler Building, to the Brooklyn Bridge and a crumbling pier on the Hudson River. We don't see the Statue of Liberty standing majestically in New York Bay, but rather we approach this colossus from behind, seemingly coming upon it unexpectedly as we wander out of the jungle. Instead of the classic view of the Guggenheim Museum stretched along Fifth Avenue, Thomas has uncharacteristically photographed it from Eighty-Ninth Street so that we see it from one end, looming out of the darkness like a ship coming out of the fog. His view of the completely deserted main hall of Grand Central Station makes one wonder what sort of civic ceremonies or religious rites could have taken place in this cavernous, temple-like interior.

The quietness that these photographs evoke, so at odds with our expectations, is at first unsettling for someone well acquainted with New York. The urban landscape may be familiar, but this is not the city that most of us know and experience. The total absence of people in Thomas' photographs is the result of shooting in the early morning hours, when even New York's streets are almost deserted, and because of the necessity of making long exposures with his view camera. With his lens shutter opens for many seconds for each exposure, moving figures did not register on the slow film that Thomas used, reinforcing the impression of the city as the site of a lost civilization.

Other artists would empty the city of human presence to abstract it, to emphasize its formal, constructed qualities, resulting in a cool, detached, visual experience. But this seems to be furthest from Thomas' intentions. The photographer's unmistakable affection for his subject comes through in these photographs. One of the fortunate consequences of shooting with little light and long exposures is the subtle luminosity that radiates from these images. This imbues an understated lushness to scenes that otherwise might feel cold and remote. The quality of the light and the rich textures in Thomas' view of Central Park's Bethesda Fountain and Terrace transform the scene into one redolent of decaying Mayan ruins on the edge of a subtropical forest.

Cumulatively, the absence of people in the images eventually draws attention to the lone presence of the photographer. Stillness, quiet, and solitude are not what one normally associates with New York or imagery of New York. Yet these are the qualities emanating from Thomas' images. His uncommon reaction to the city adds a very personal layer of meaning to the scenes in these photographs.

Thomas relates a story of how, needing time to think and clear his head during a stressful time in his photographic career, he undertook a hike to Italy from his home outside of Munich. Later in the same conversation, discussing his New York work, he described how he prepared to set out to photograph in the early morning hours: putting on his hiking shoes; placing his view camera in his pack; and leaving his apartment before sunrise. With *New York Sleeps* Thomas has generously taken us along on a meditative *wanderung* through a city most people experience as one of the loudest and busiest places on earth. His photographs make evident that there is no New York, only versions of New York. Christopher Thomas has presented us with a New York as a place for introspection and contemplation. The photographer may not have come seeking anything, but it seems that he has found something in New York that eludes most of us.

I

FIFTH AVENUE

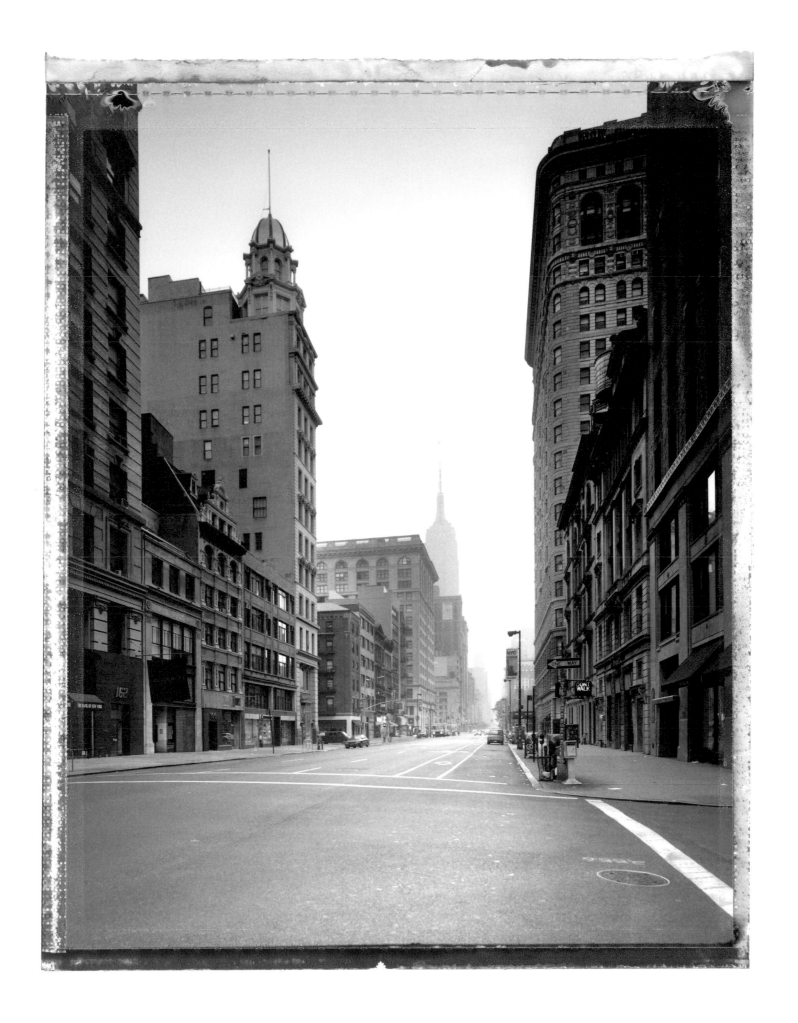

GRAND CENTRAL TERMINAL I

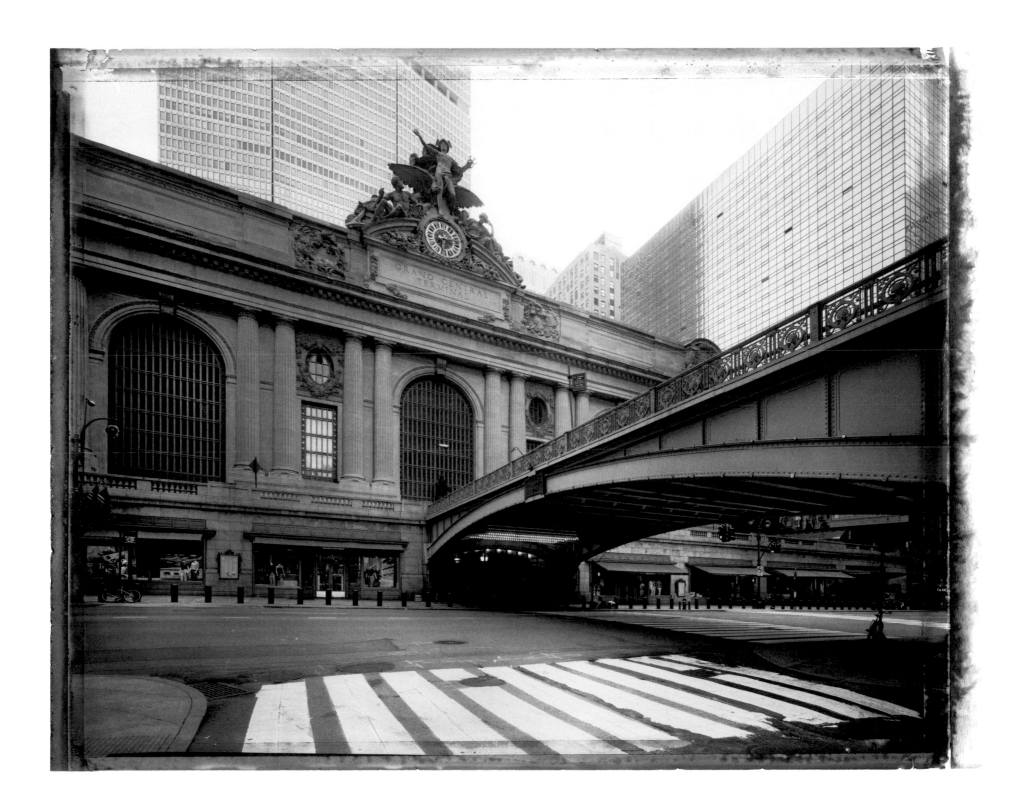

GRAND CENTRAL TERMINAL II

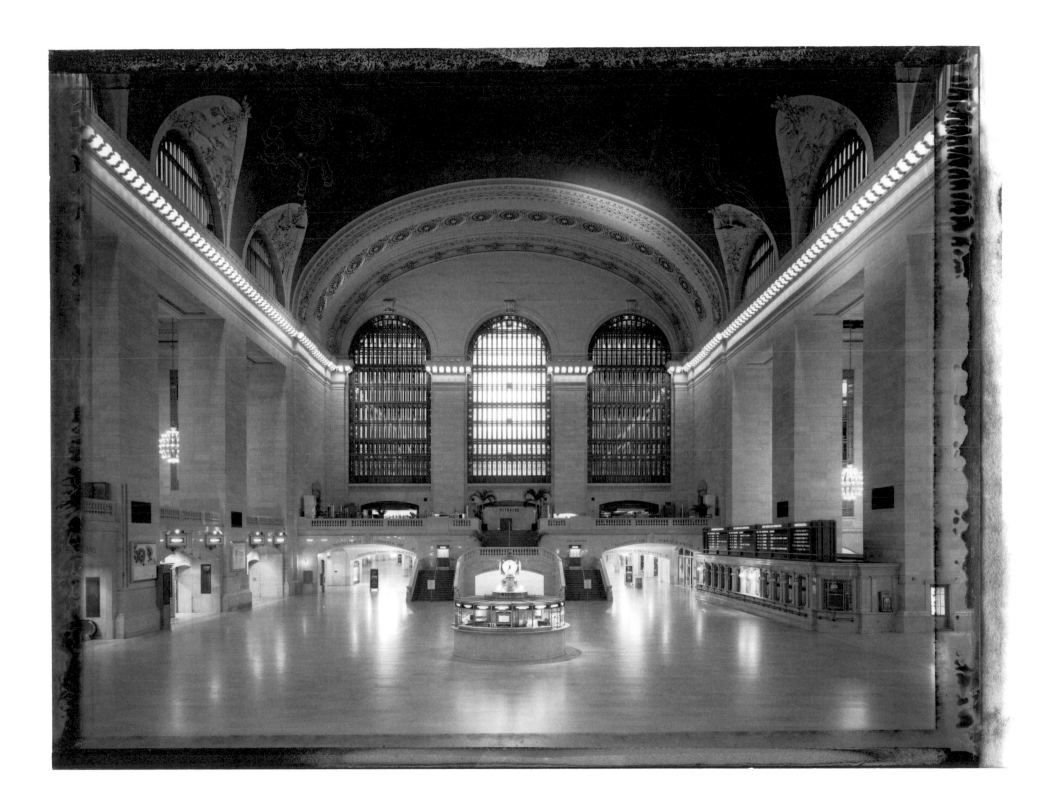

GRAND CENTRAL TERMINAL AND CHRYSLER BUILDING

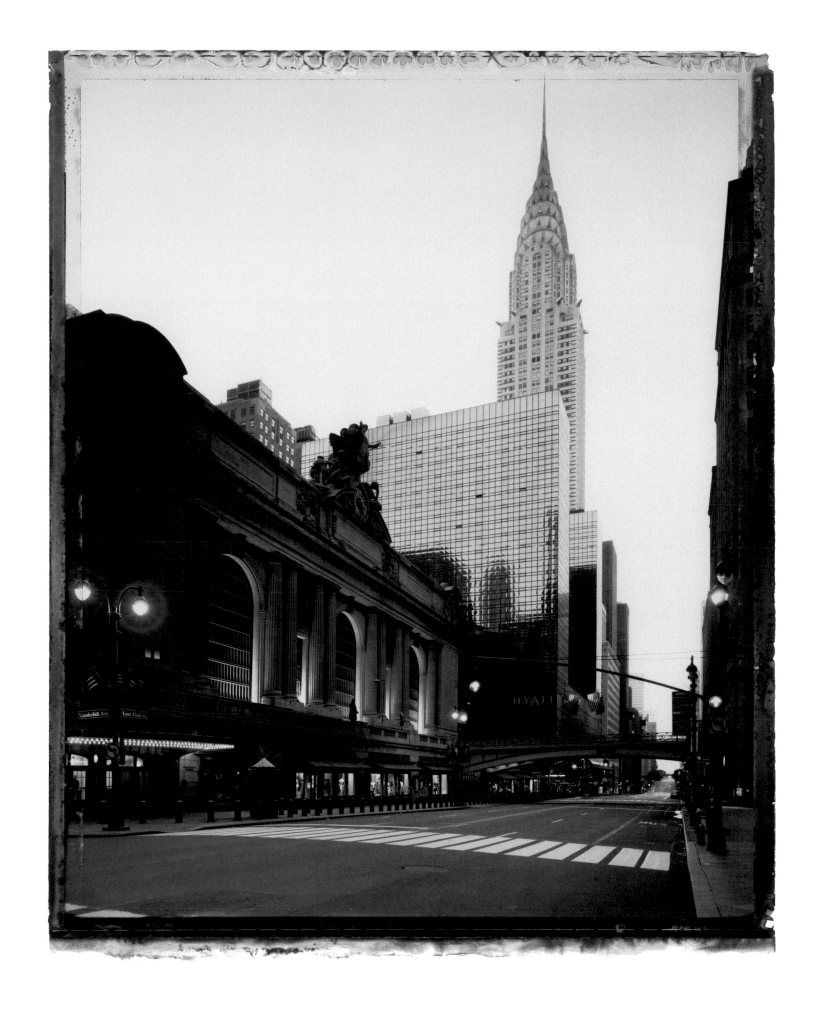

THE PLAZA HOTEL

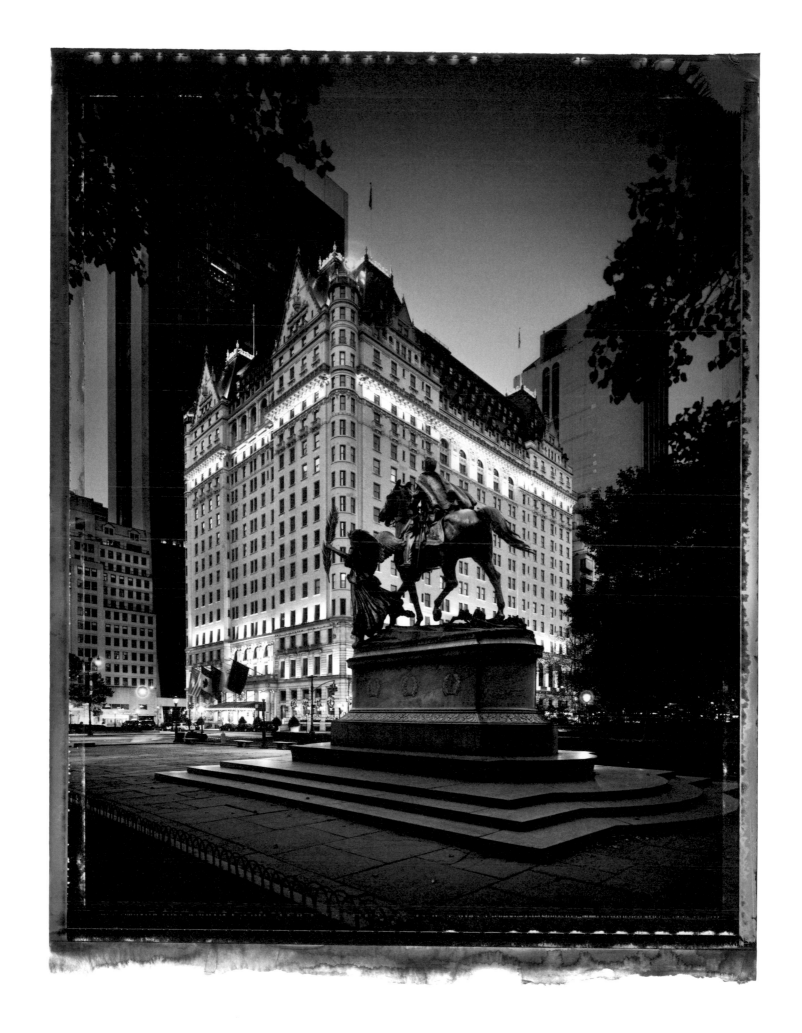

COLUMBUS CIRCLE COLUMN

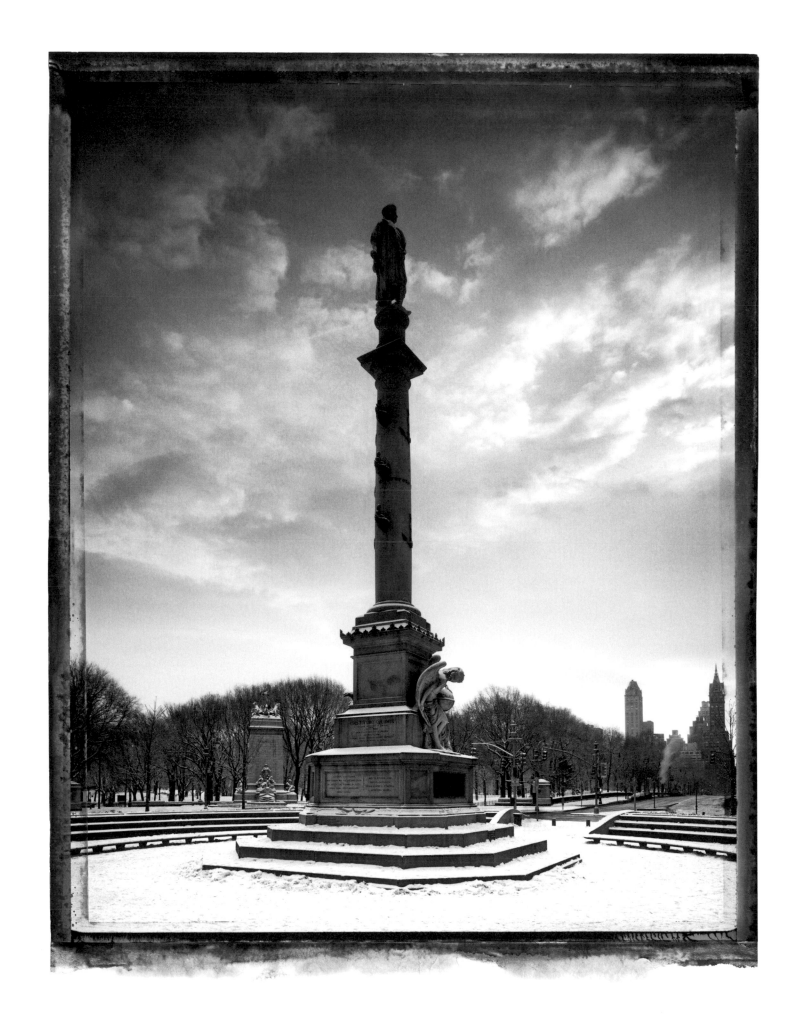

RADIO CITY MUSIC HALL

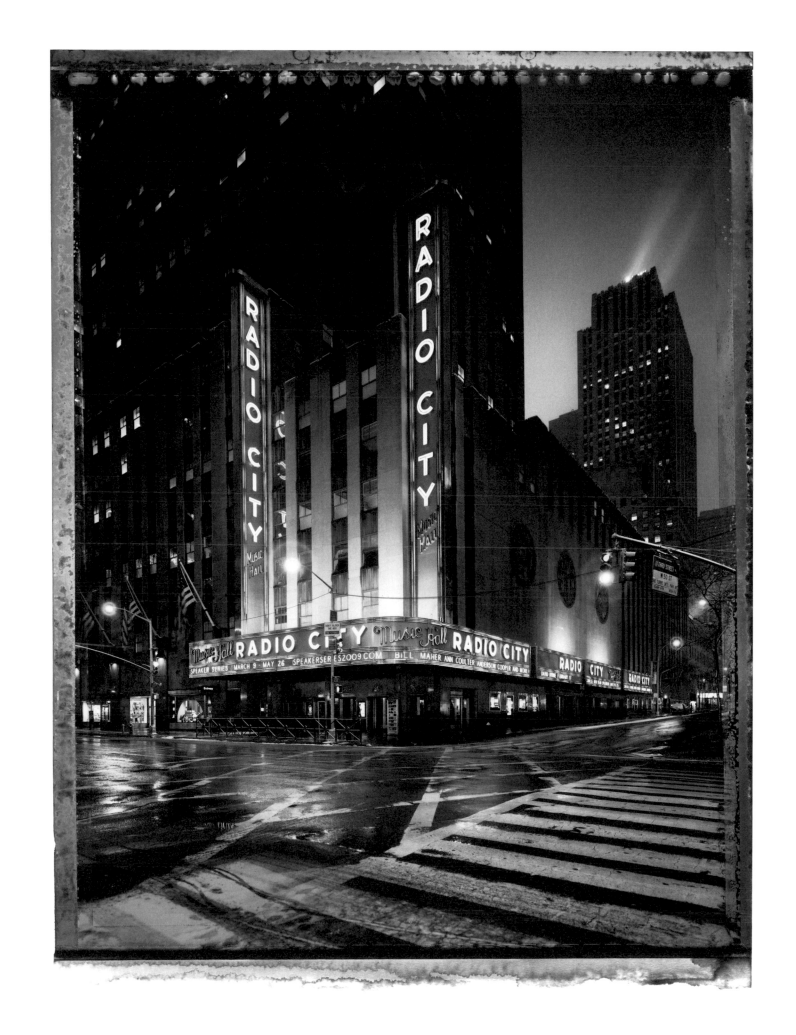

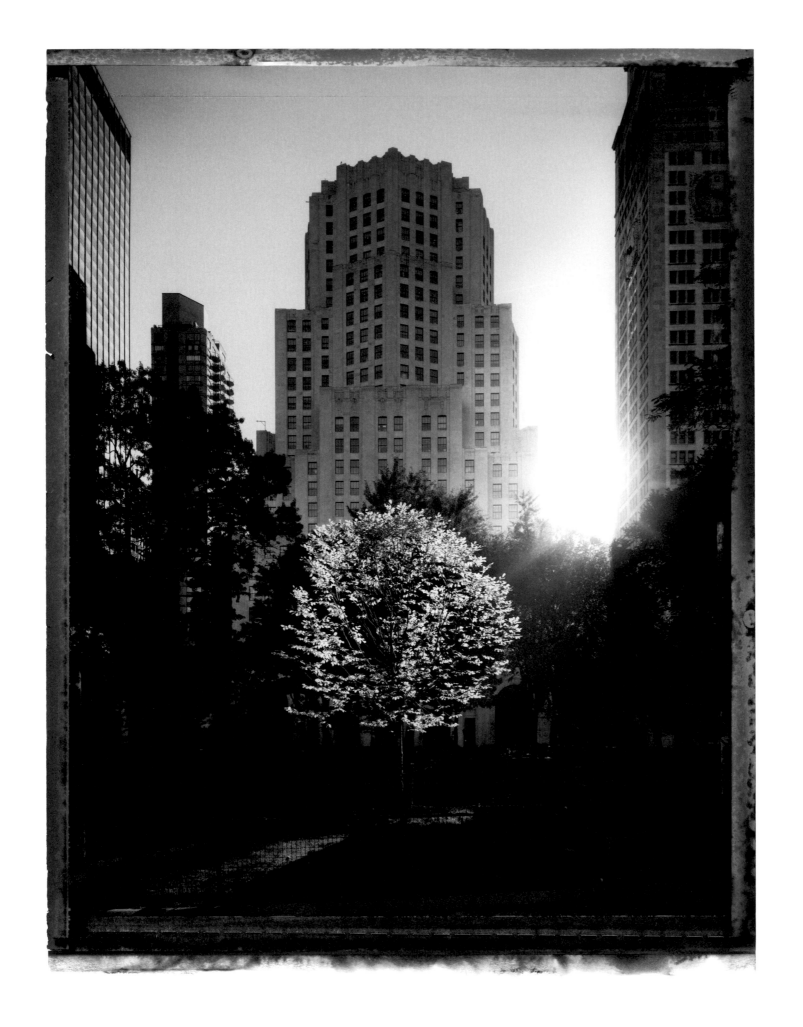

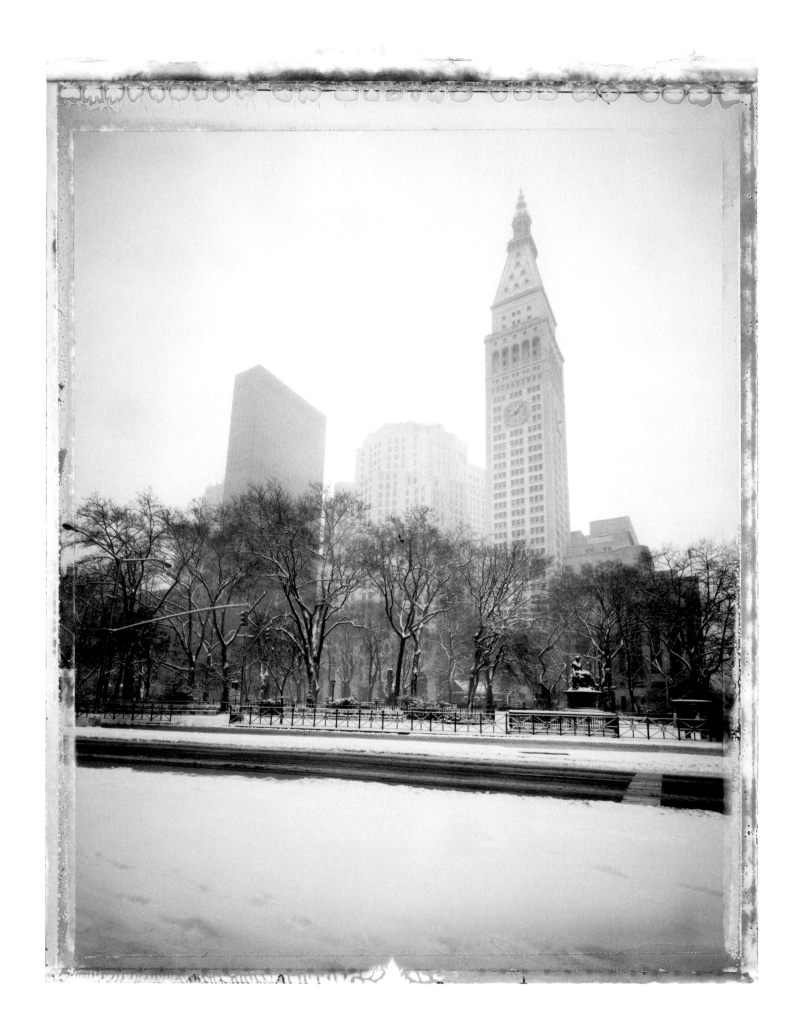

UNITED NATIONS HEADQUARTERS

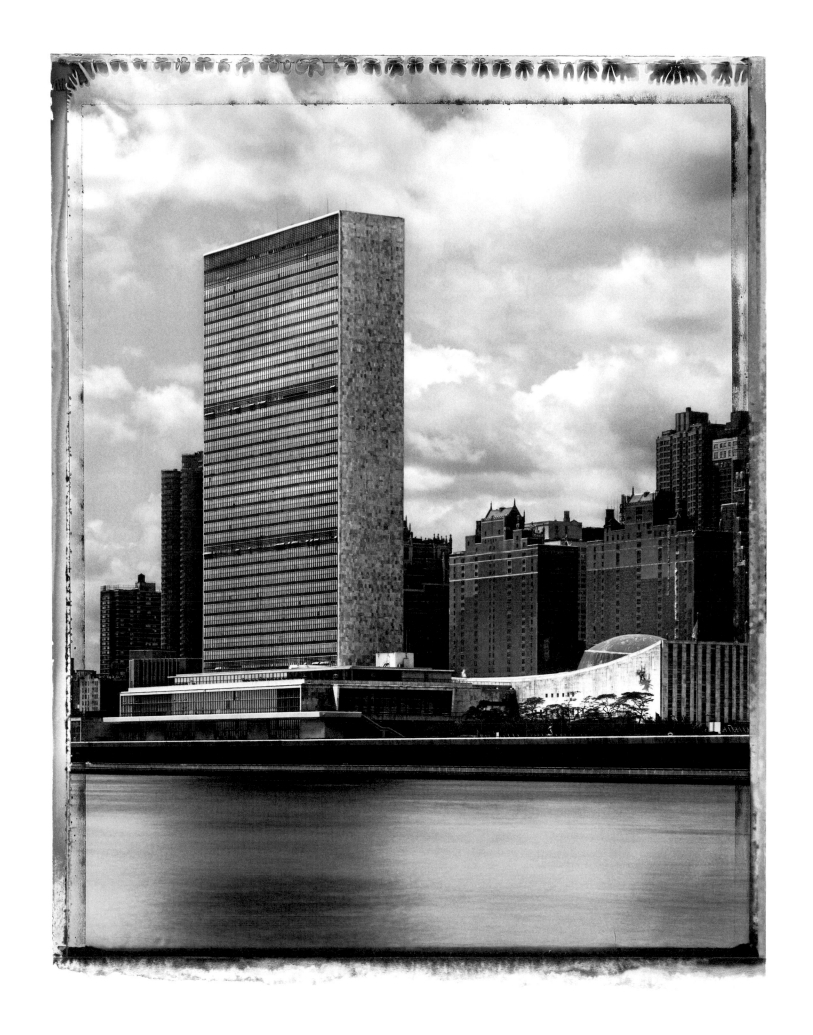

GRACE CHURCH

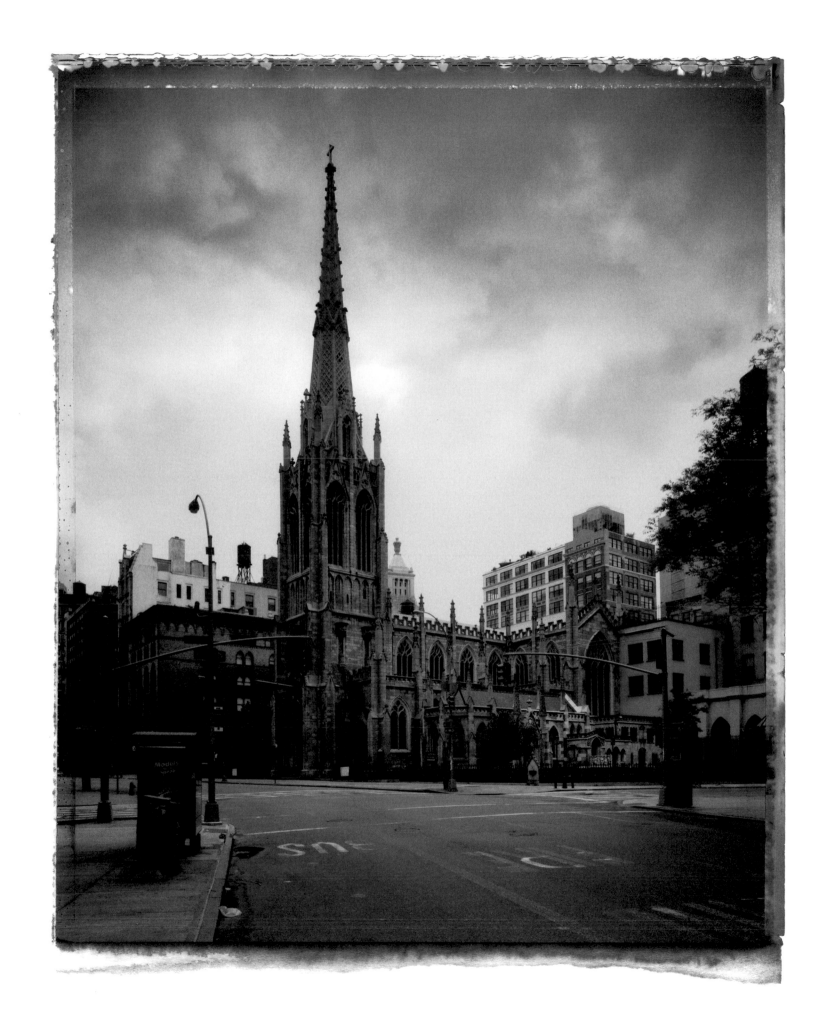

WOMEN'S COURT

TIMES SQUARE

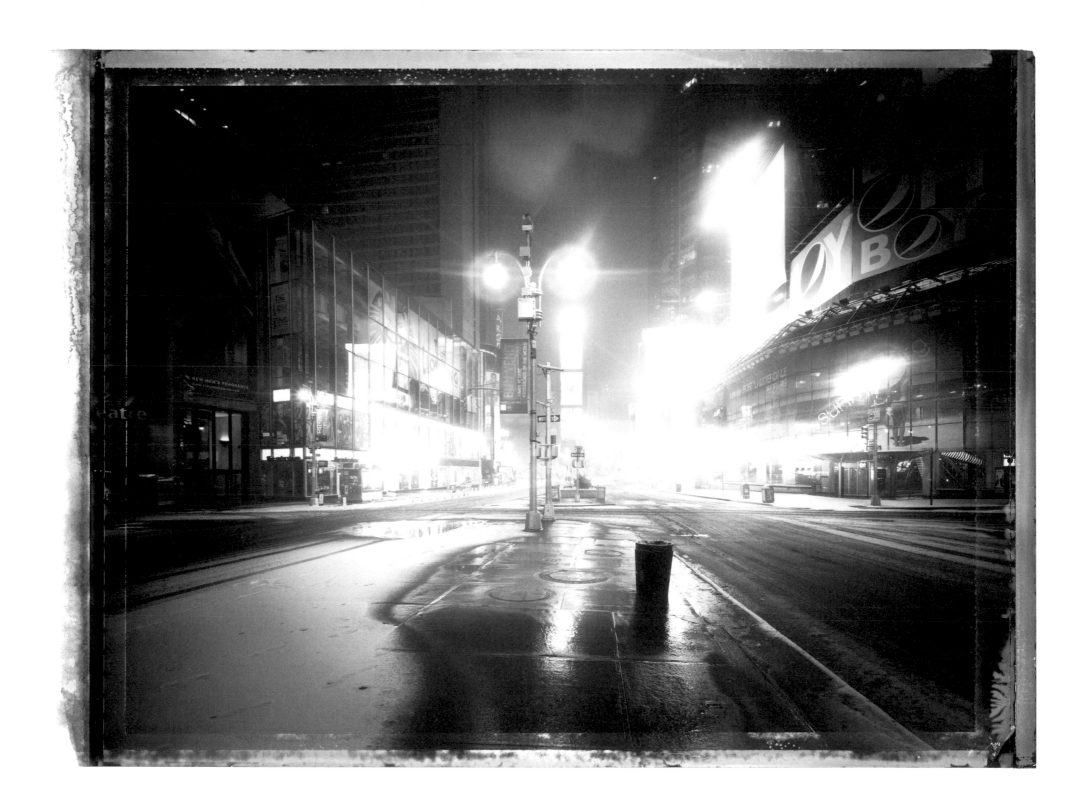

UNION SQUARE

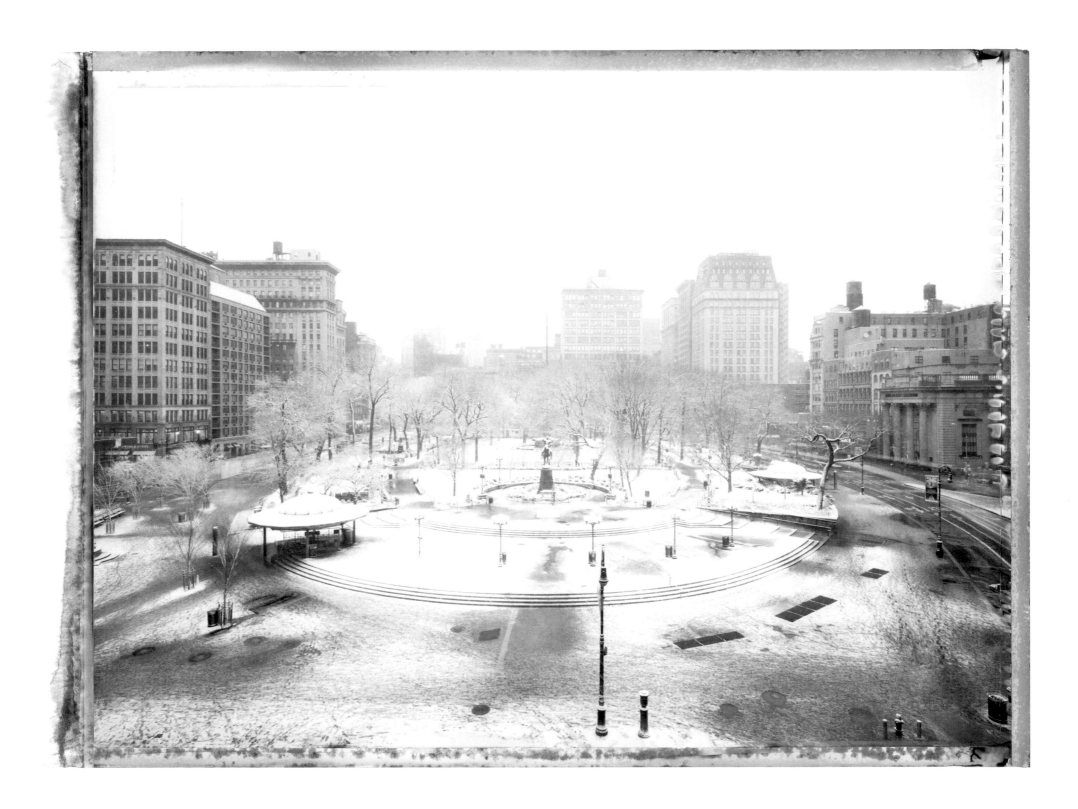

SOLOMON R. GUGGENHEIM MUSEUM

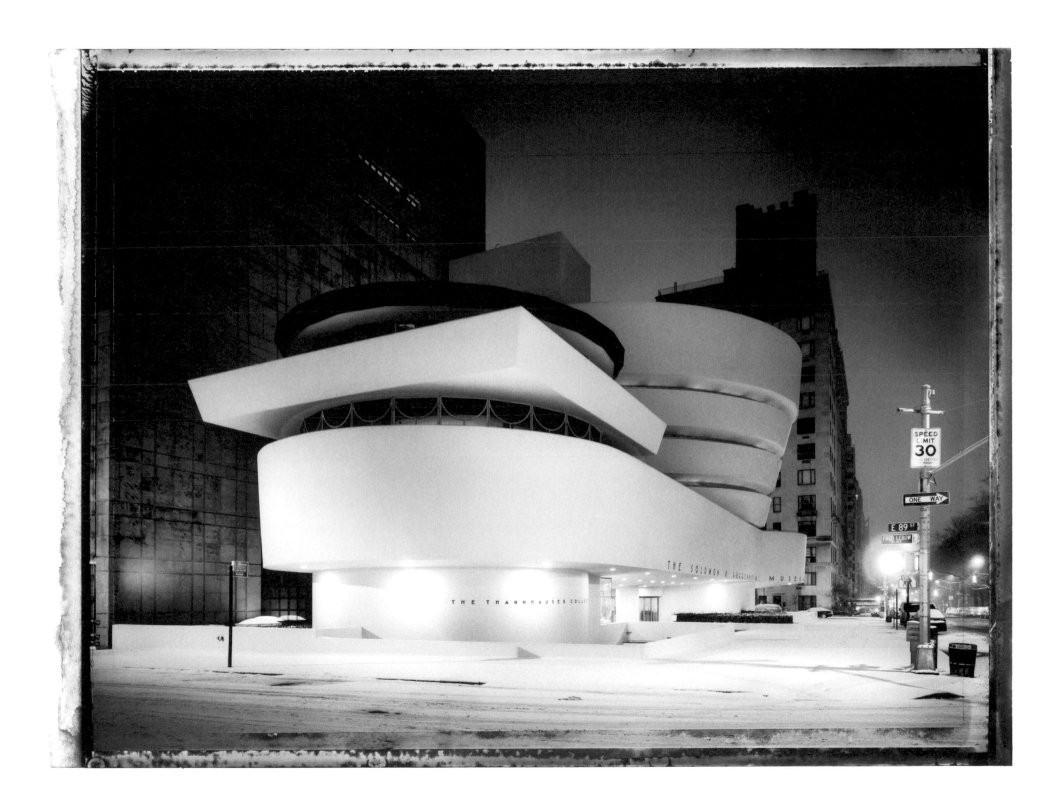

GRAND STREET

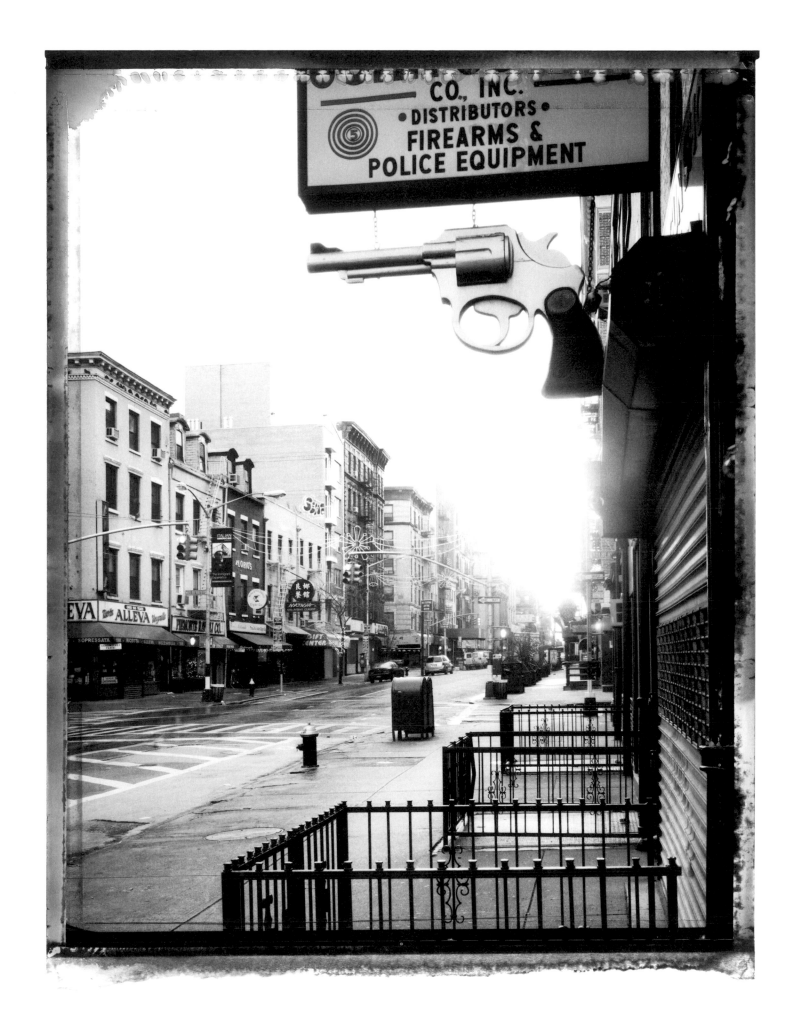

CHINA TOWN

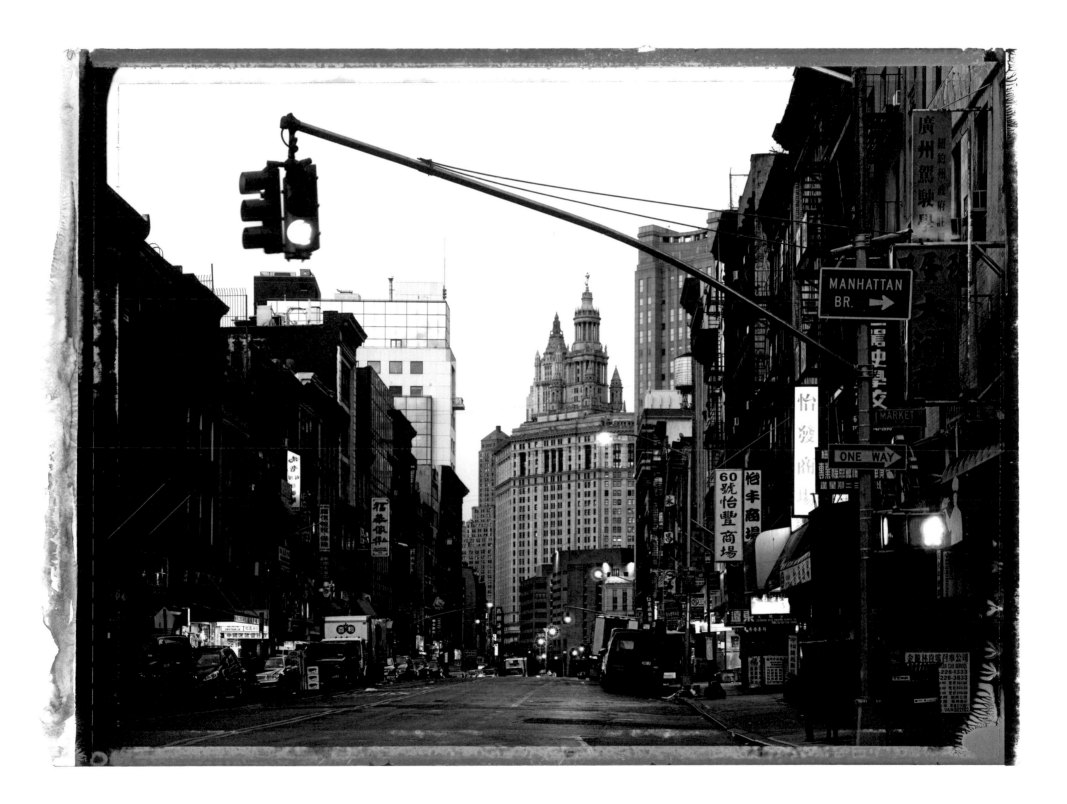

BROOME STREET

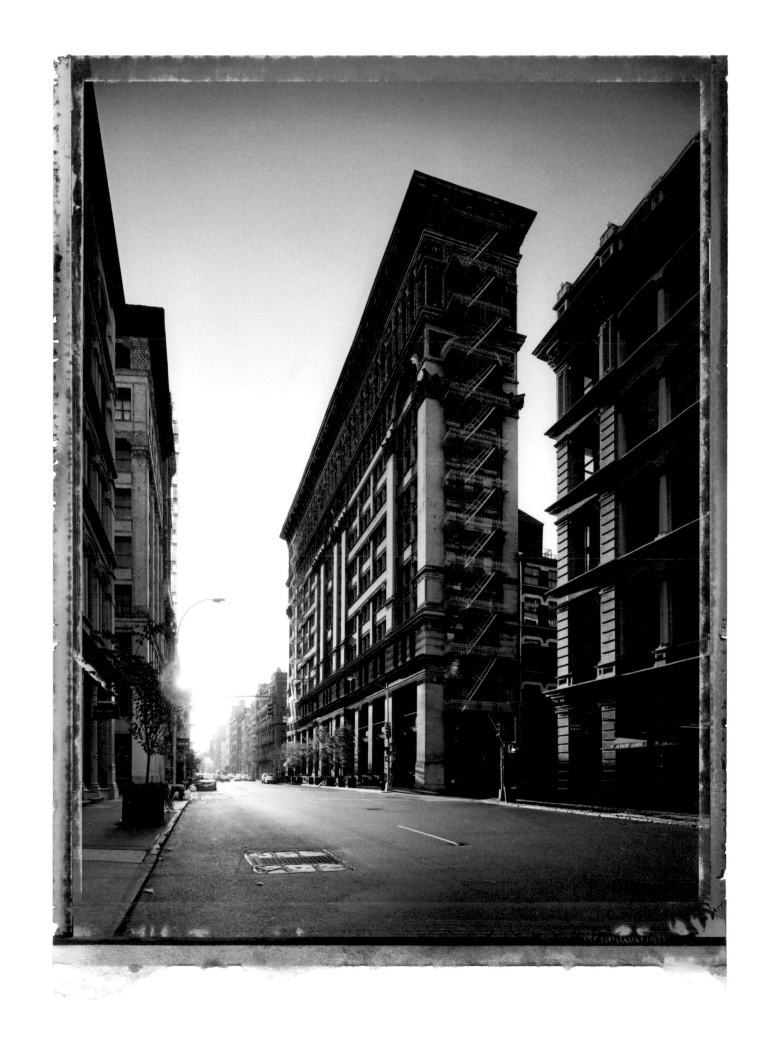

WOOLWORTH BUILDING

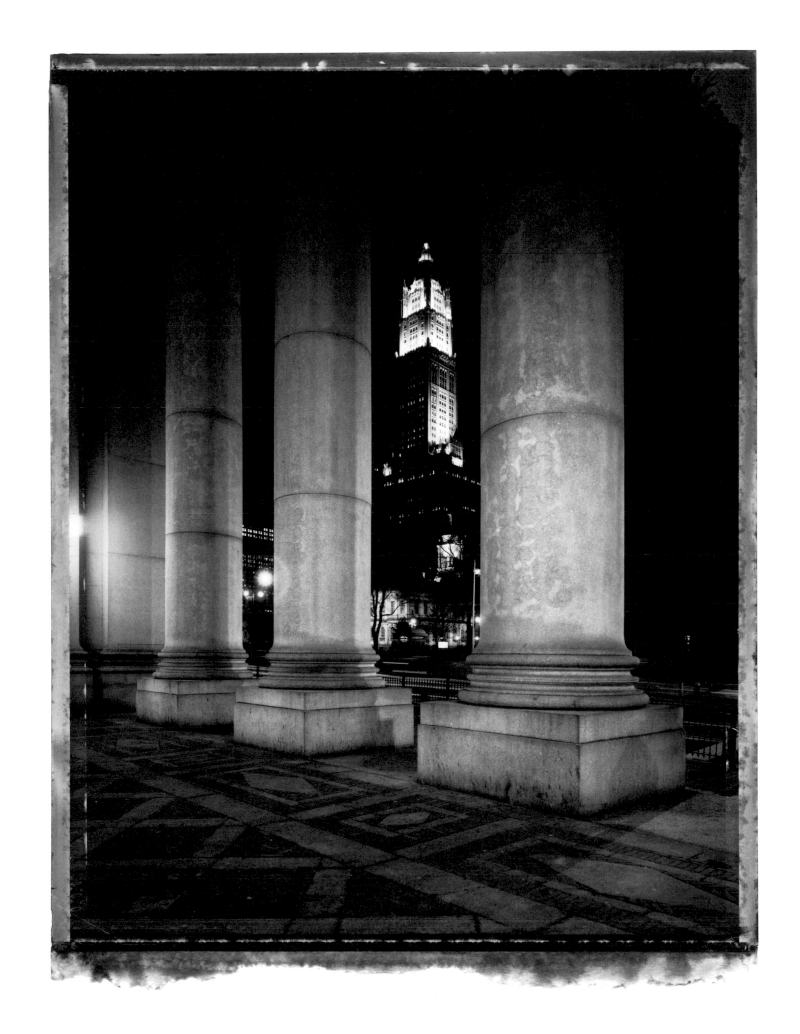

THE JAMES WATSON HOUSE

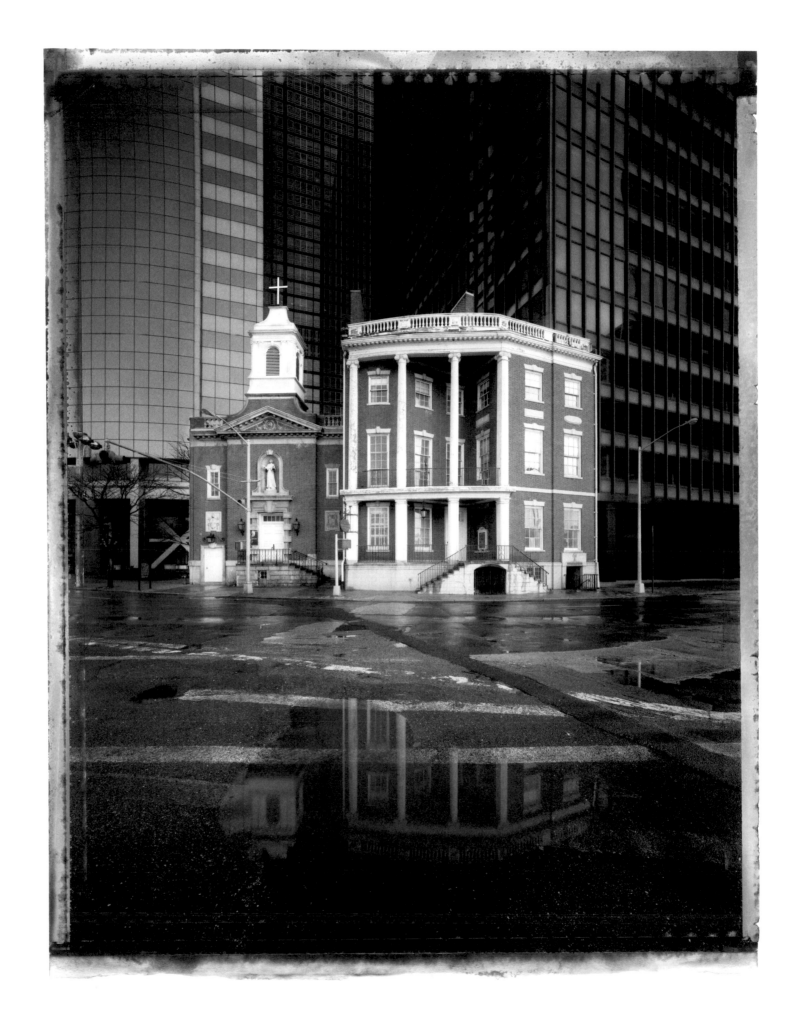

WALL STREET

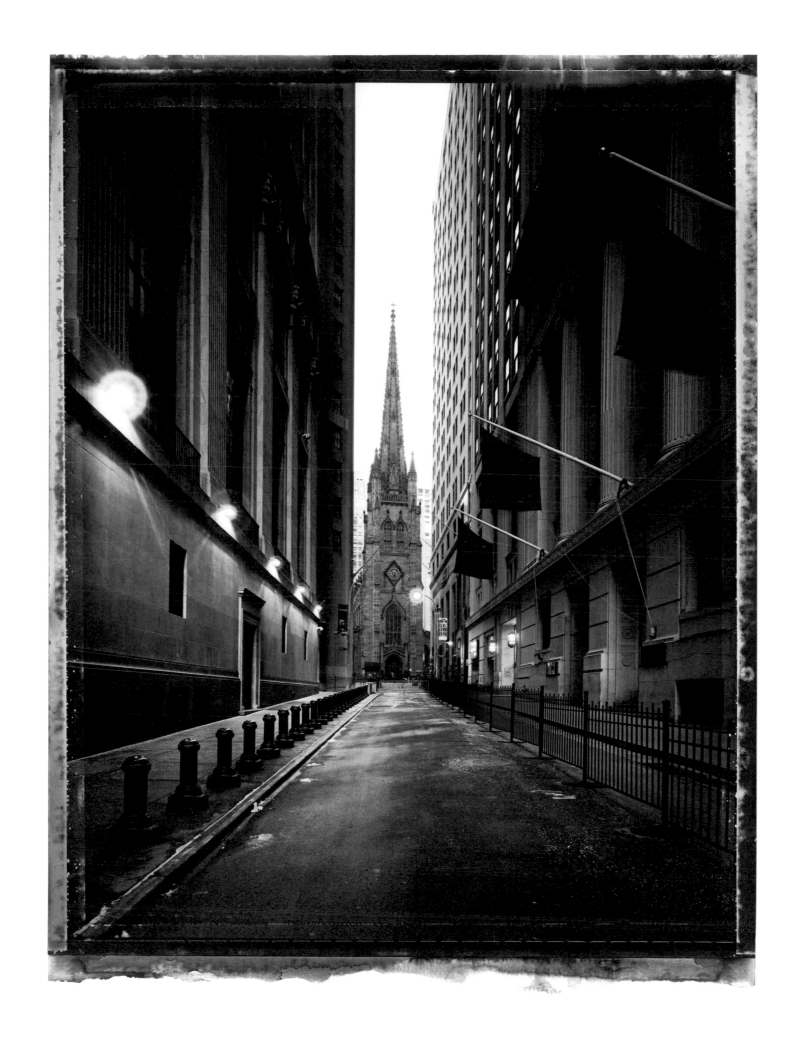

SUBWAY STATION AT 125TH STREET

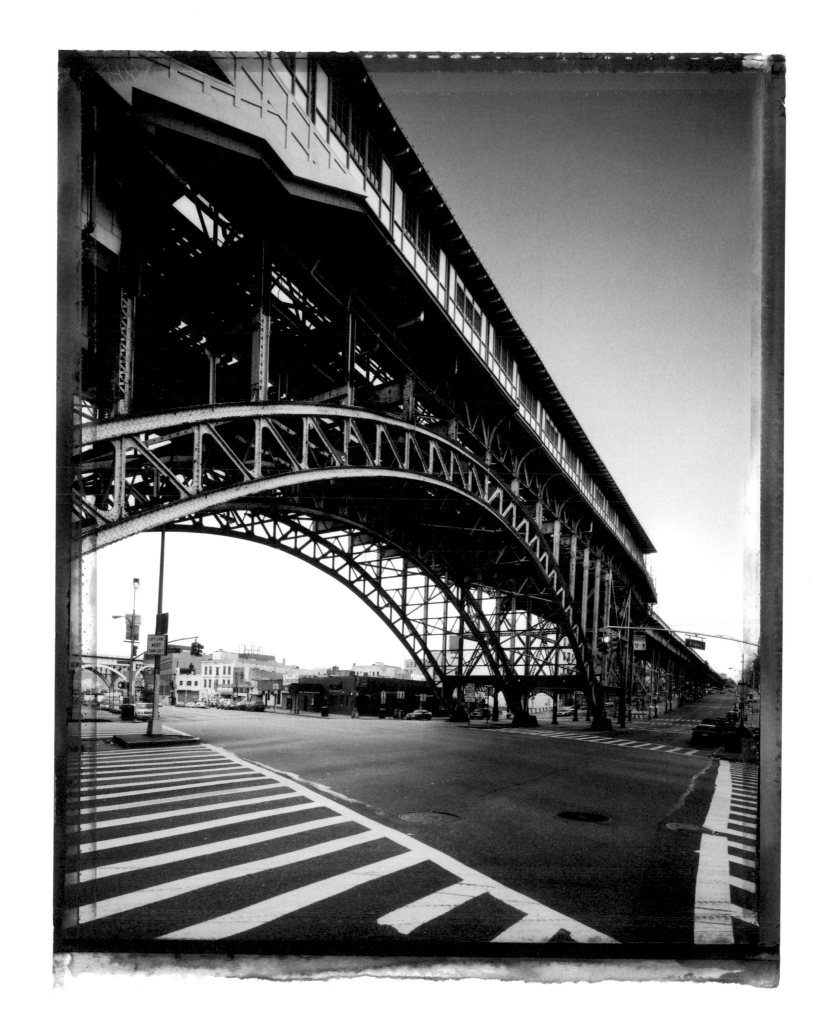

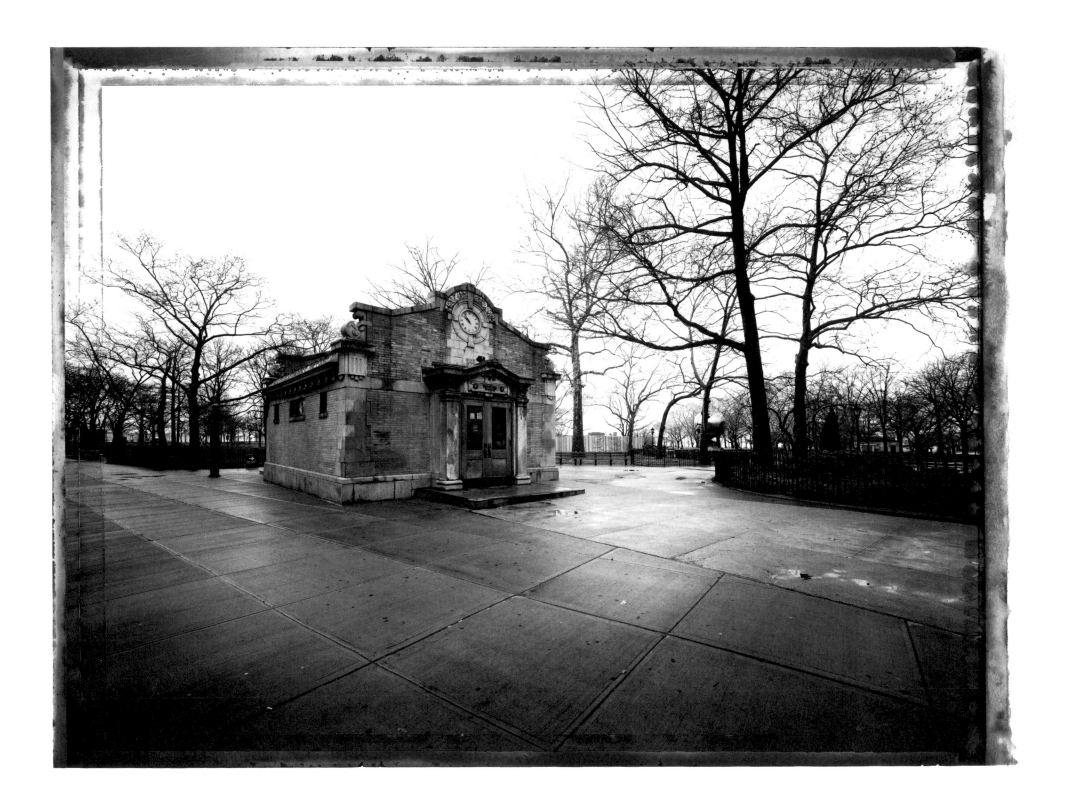

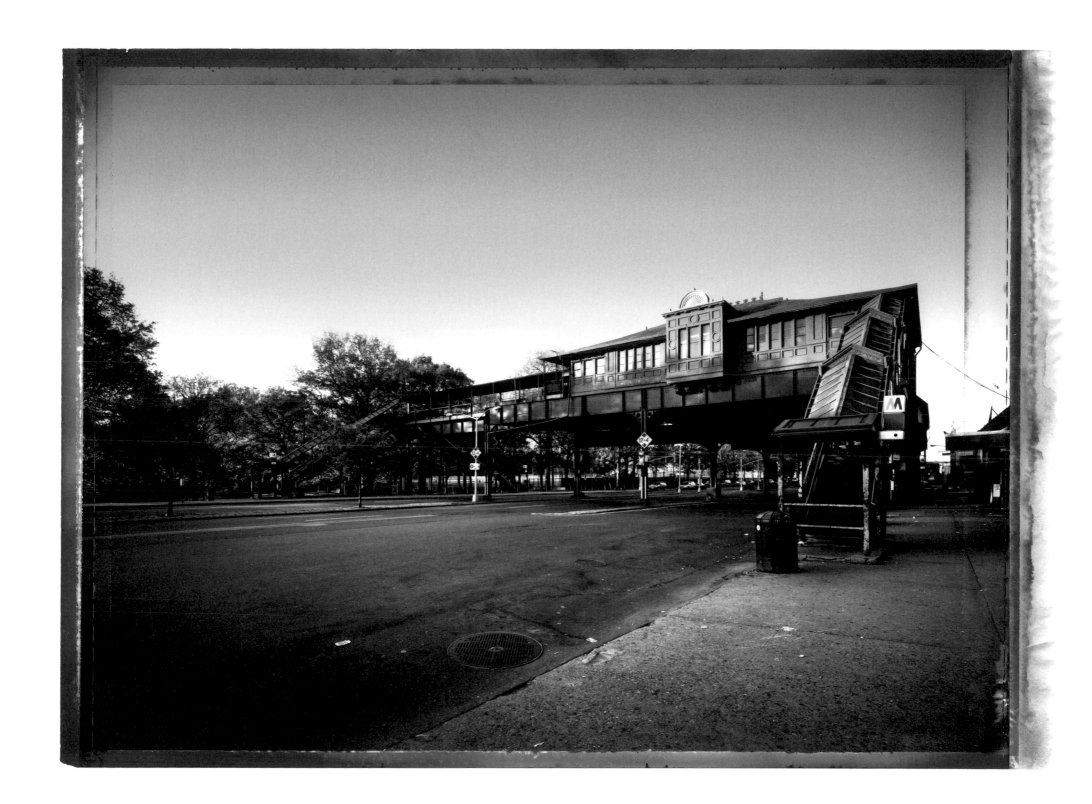

UNITED PALACE THEATER

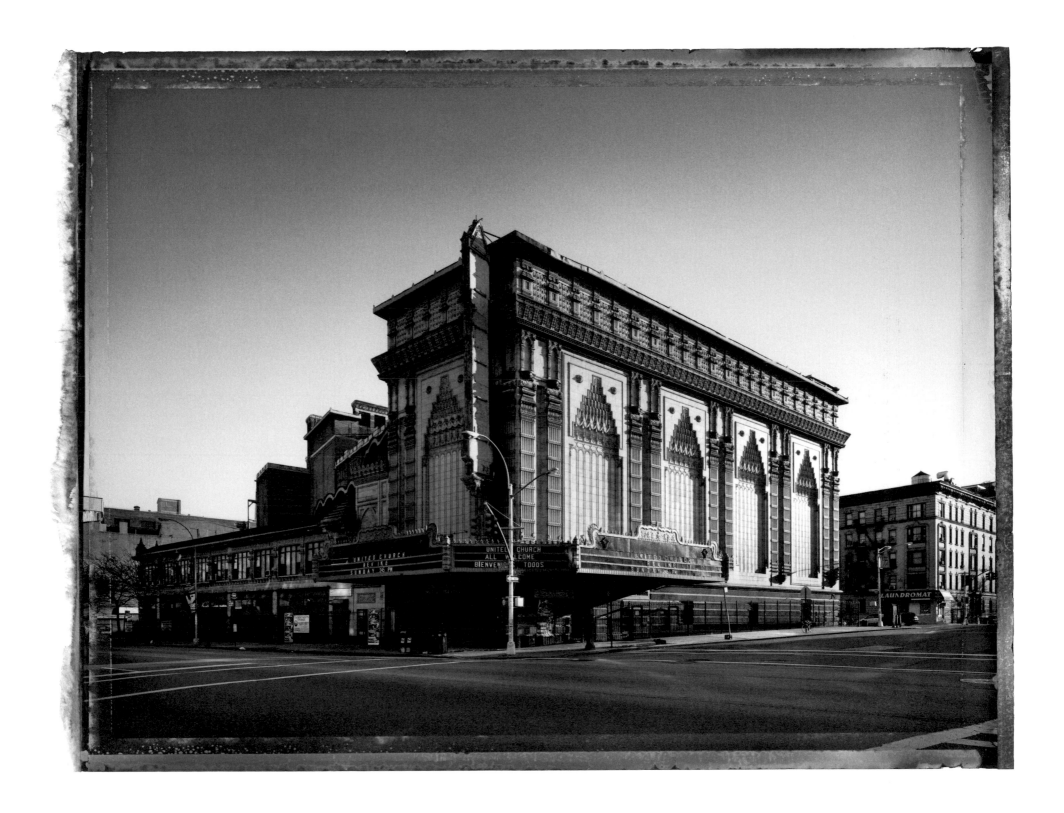

II

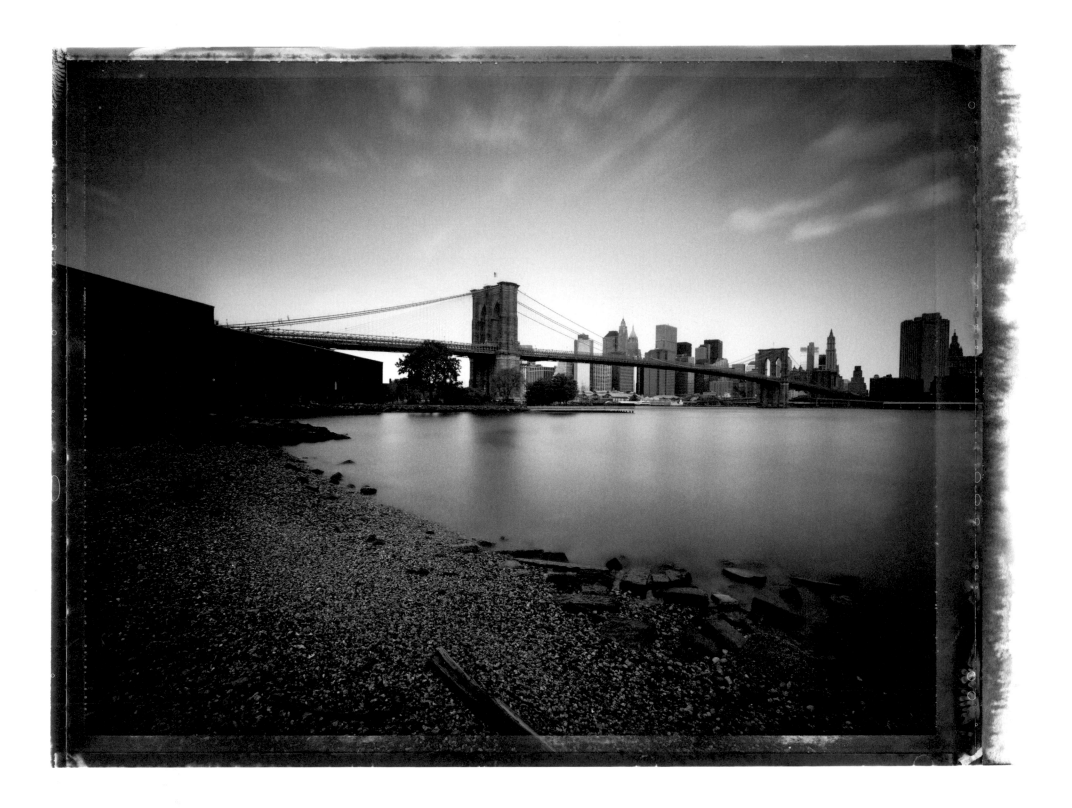

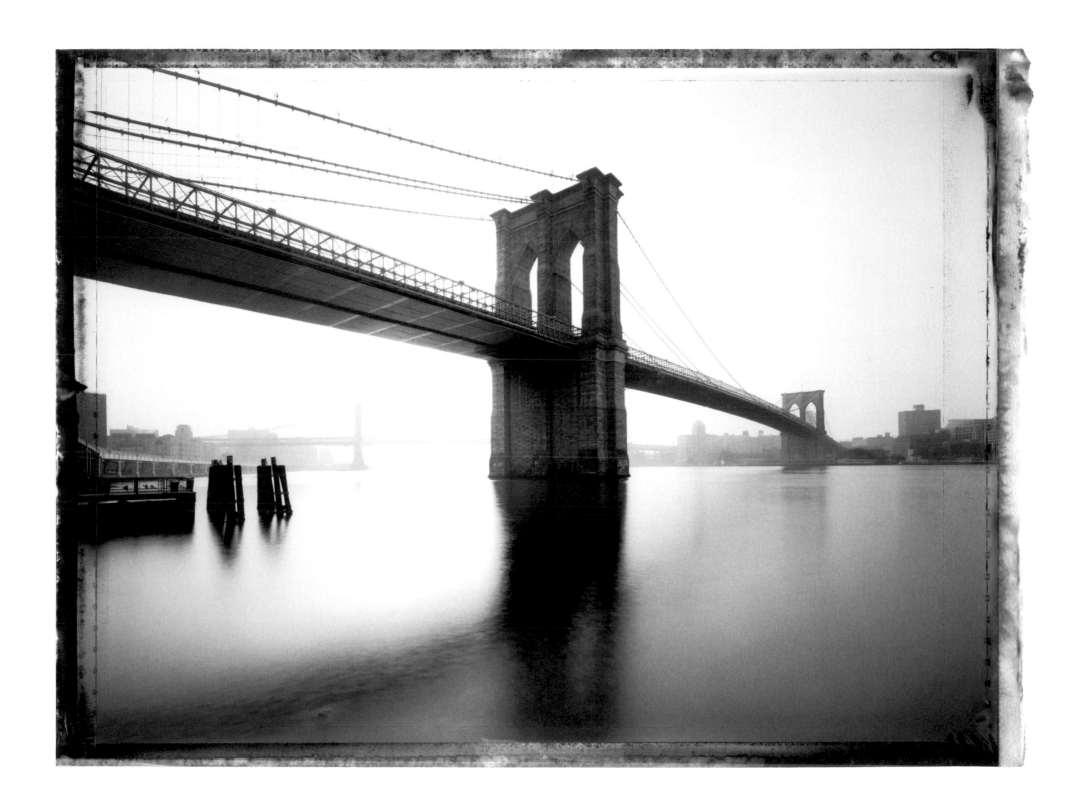

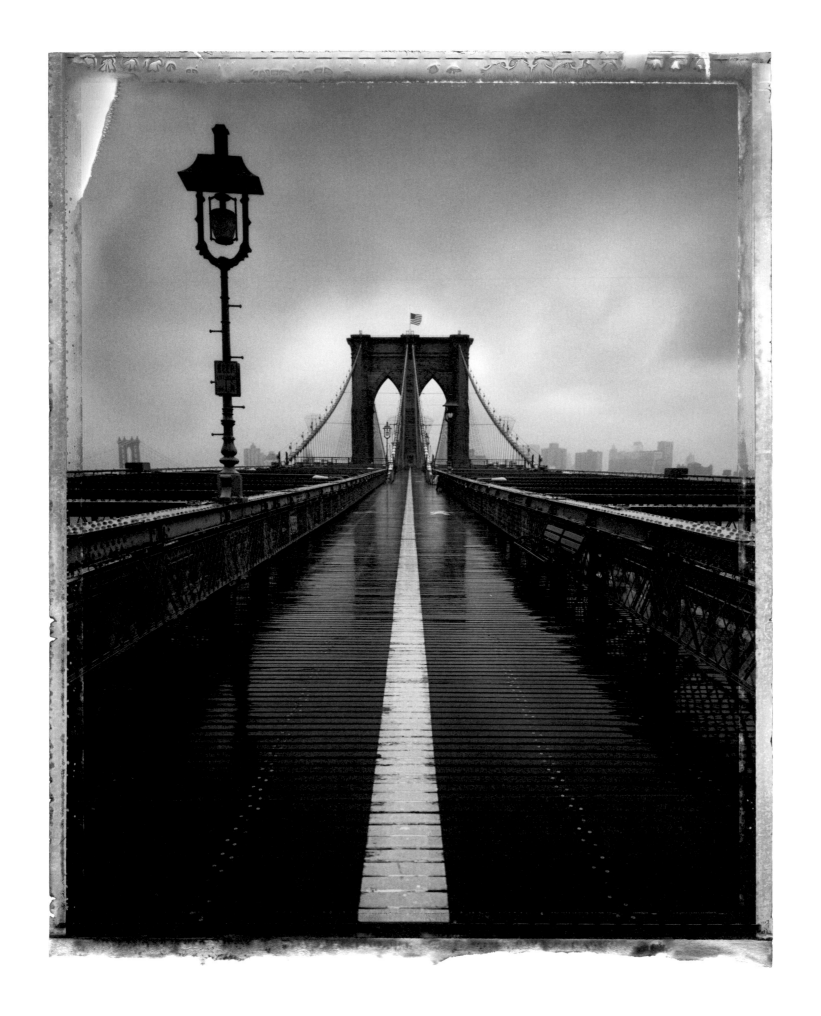

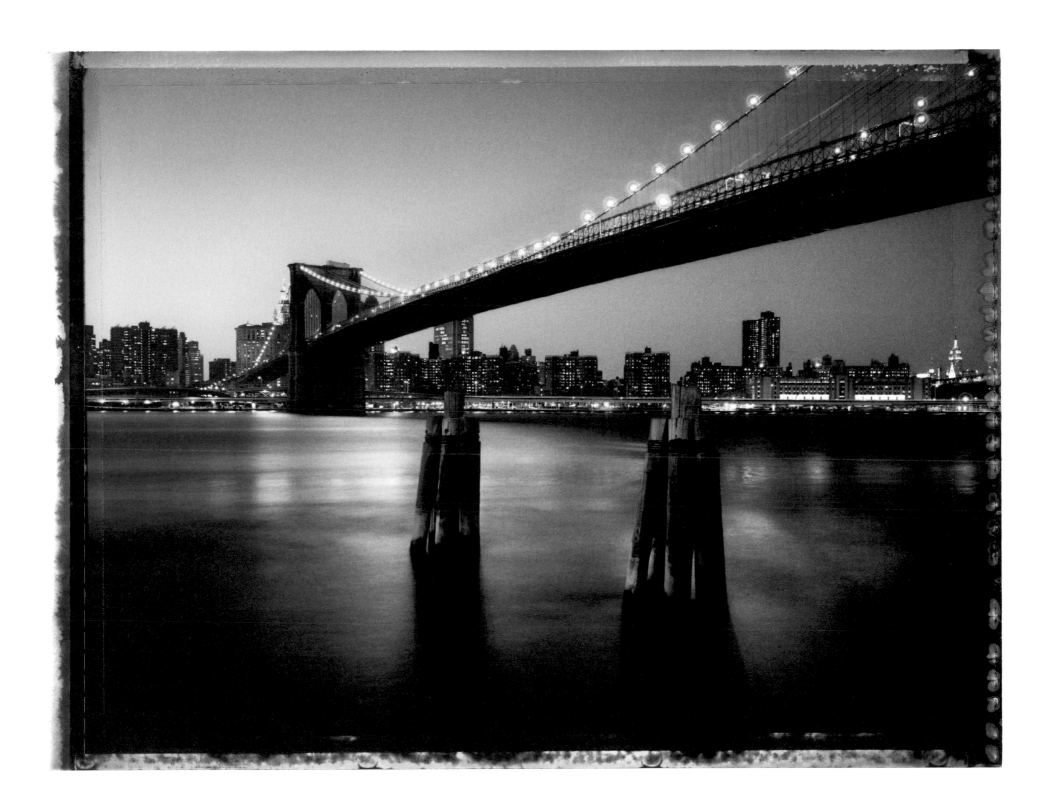

WILLIAMSBURG BRIDGE

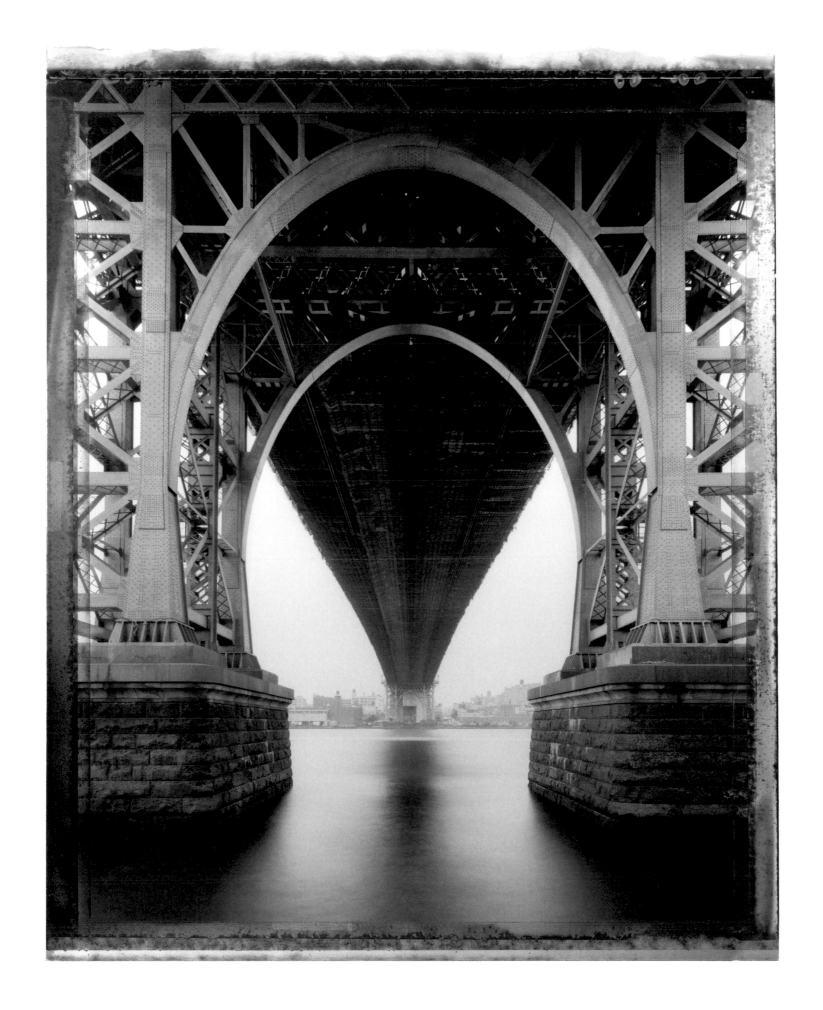

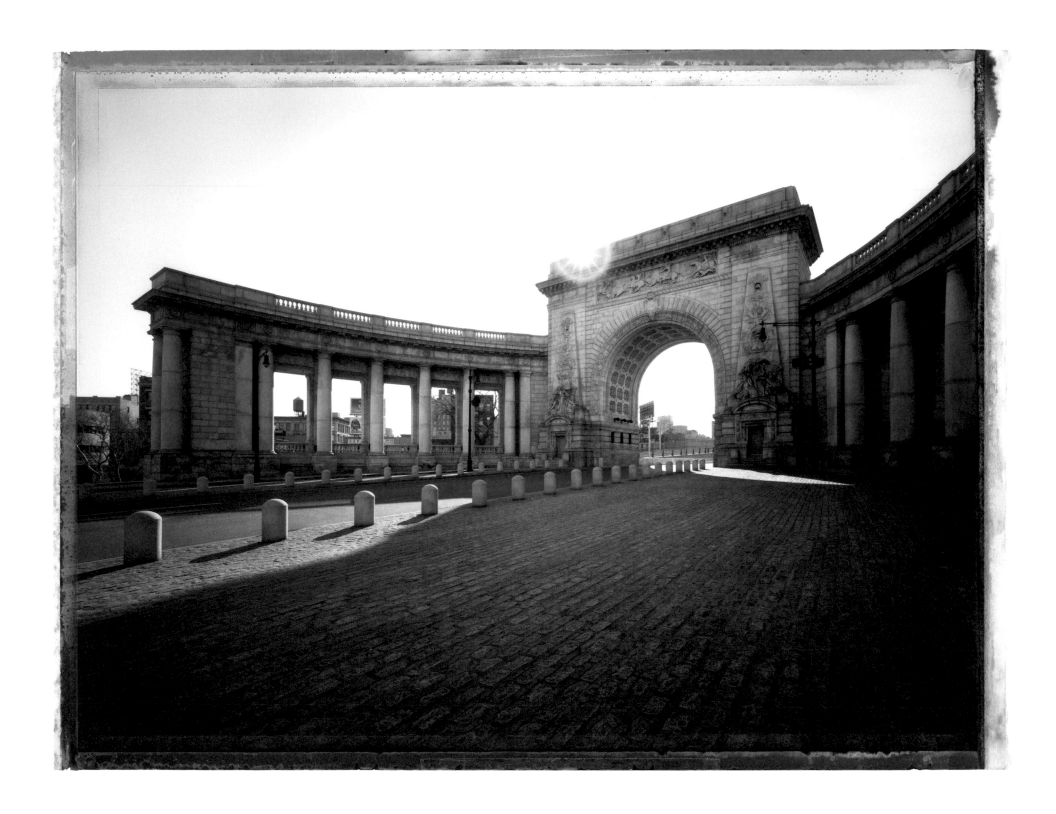

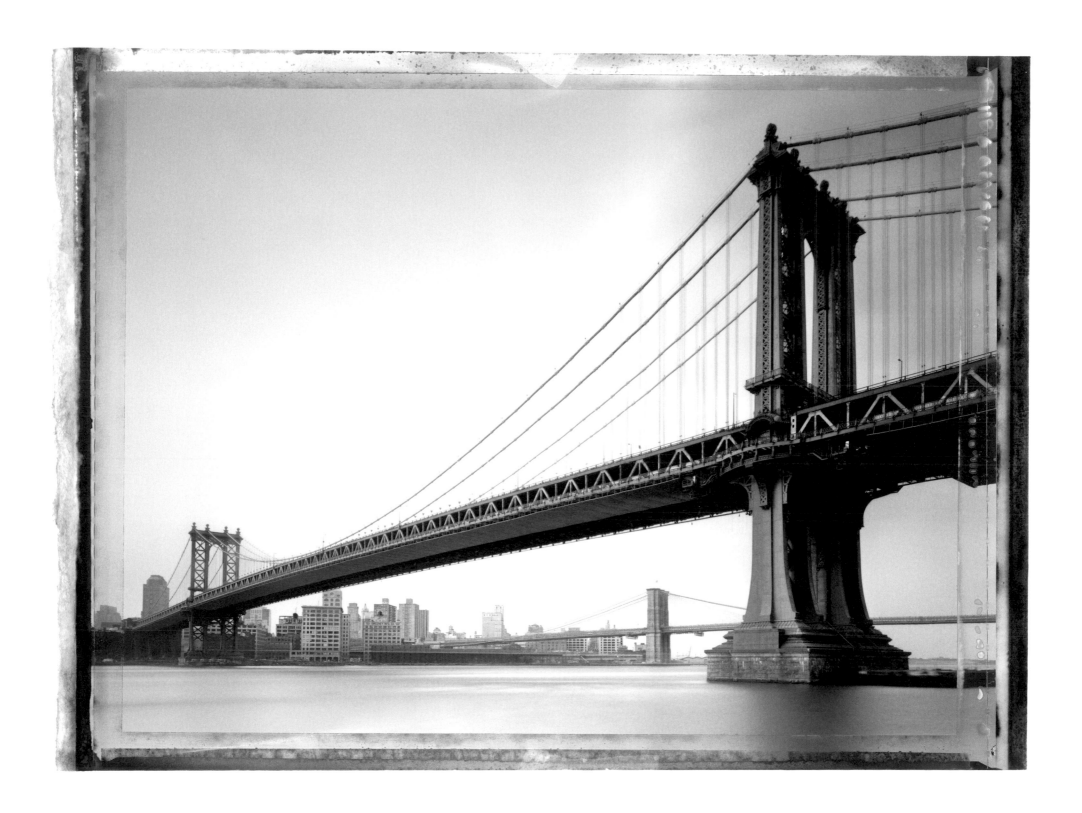

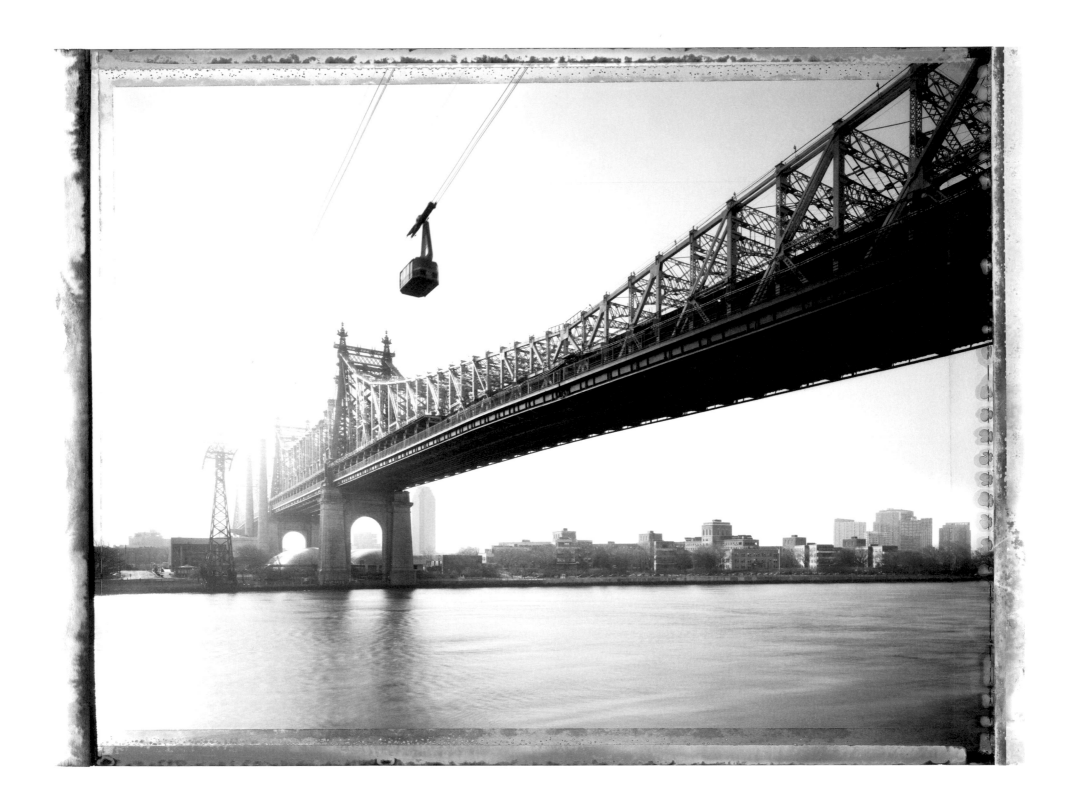

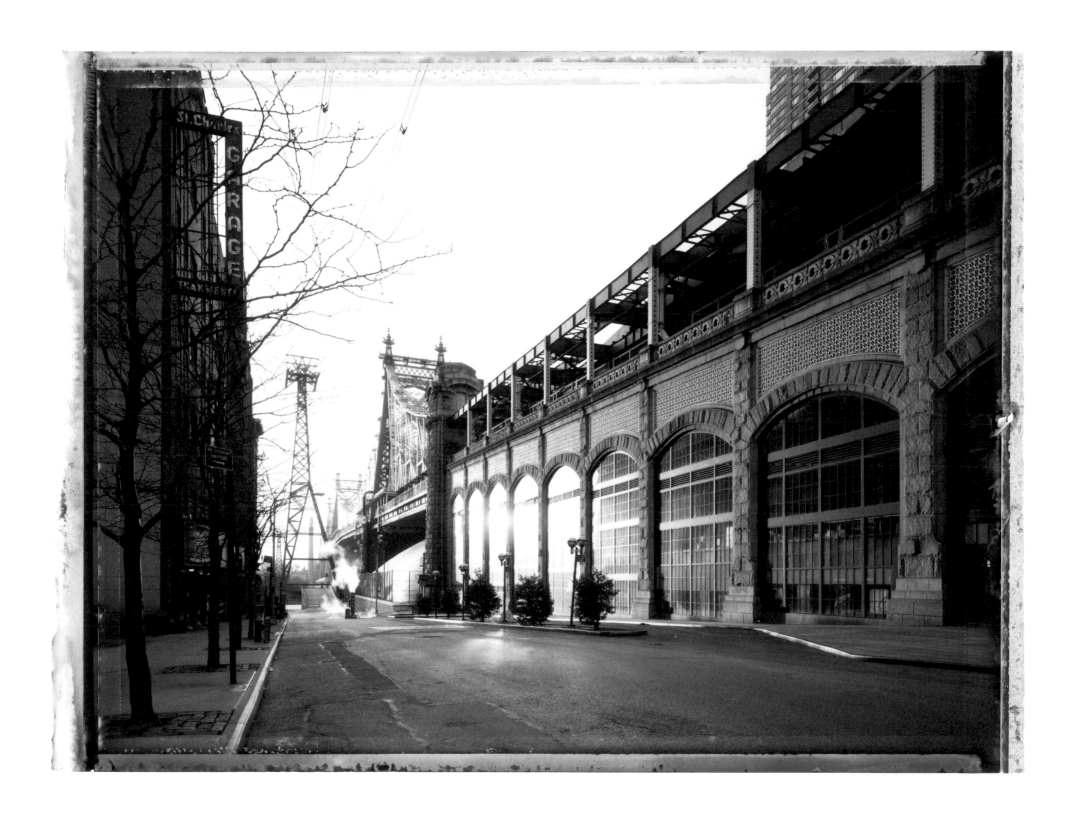

LITTLE RED LIGHTHOUSE, GEORGE WASHINGTON BRIDGE

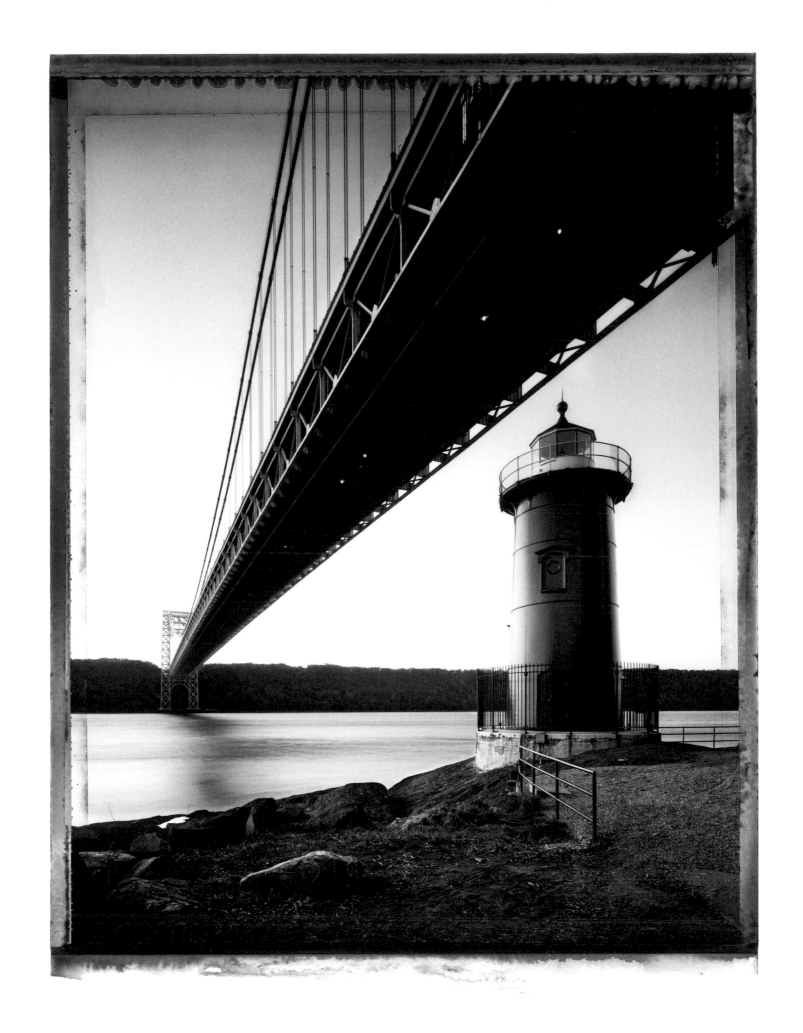

VERRAZANO NARROWS BRIDGE

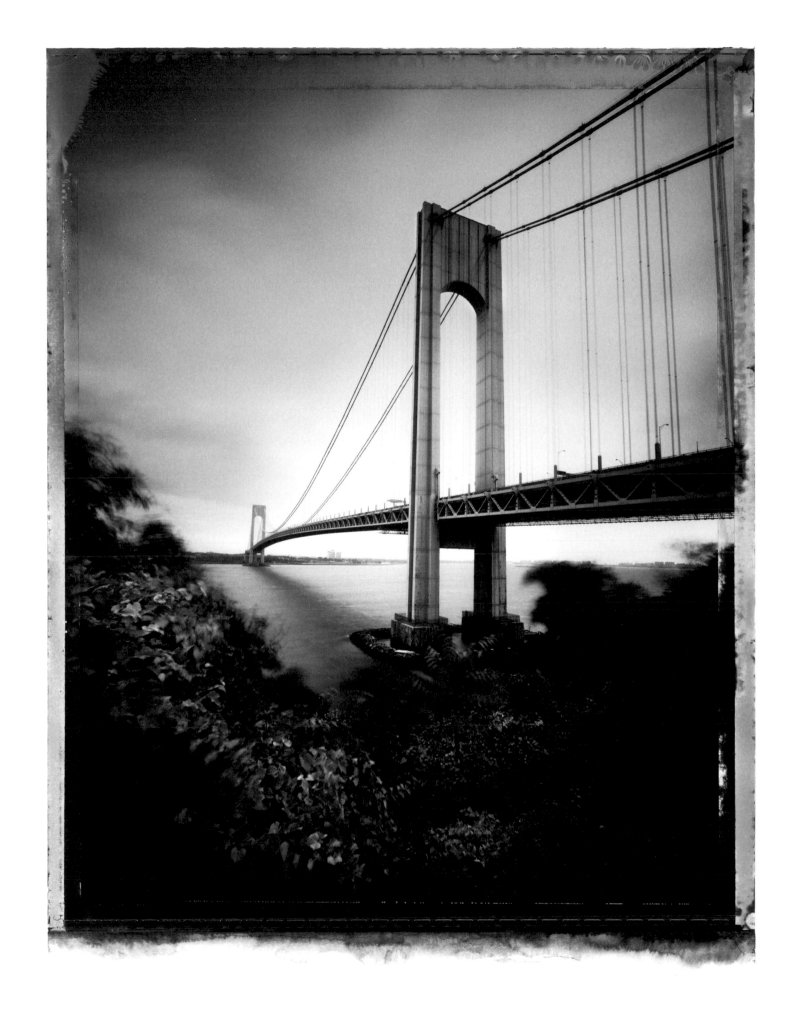

III

PIER A

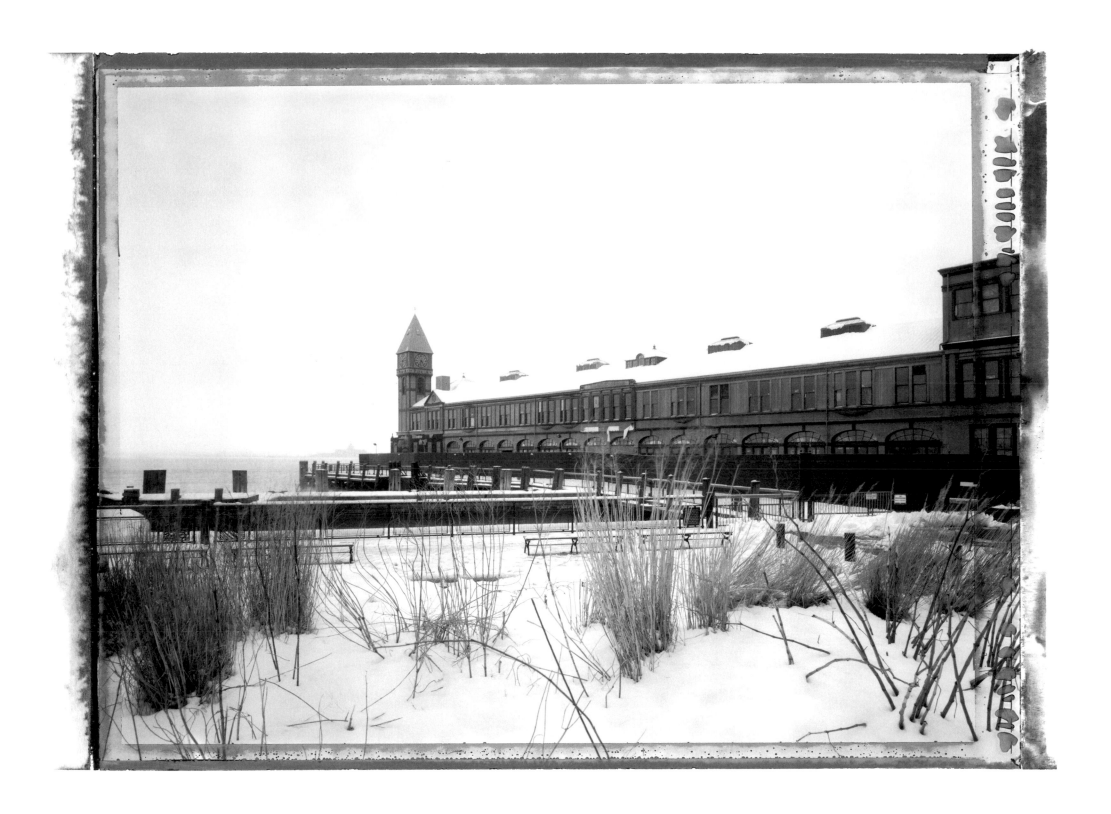

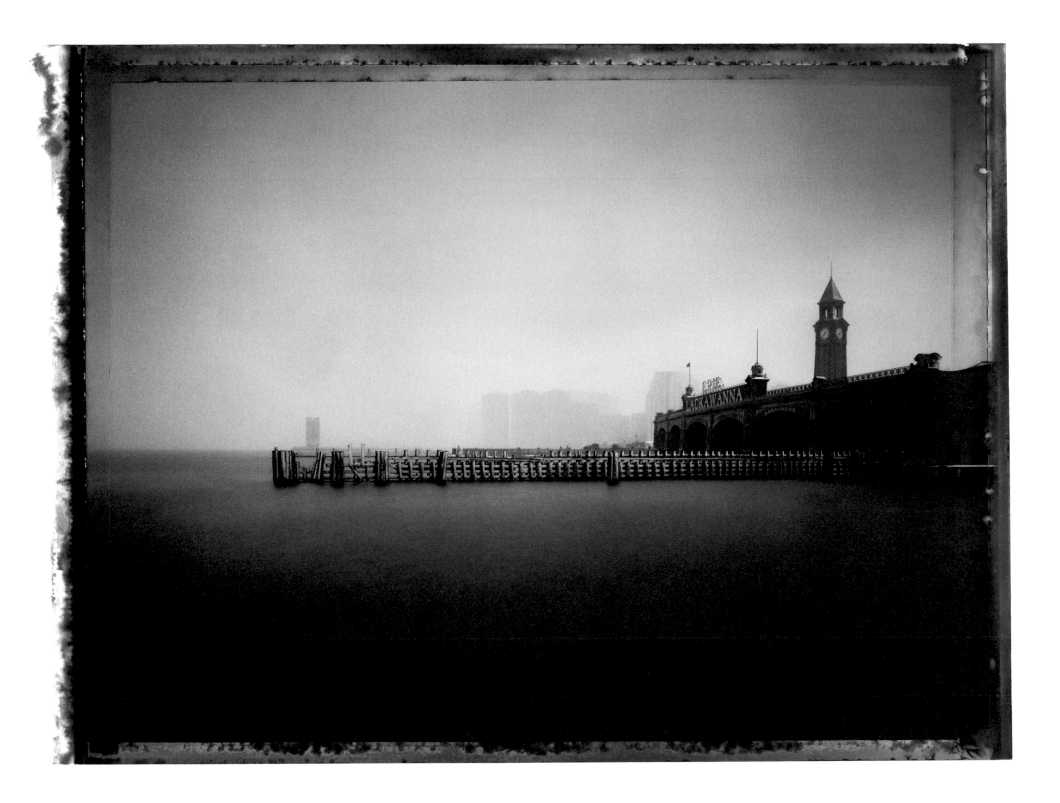

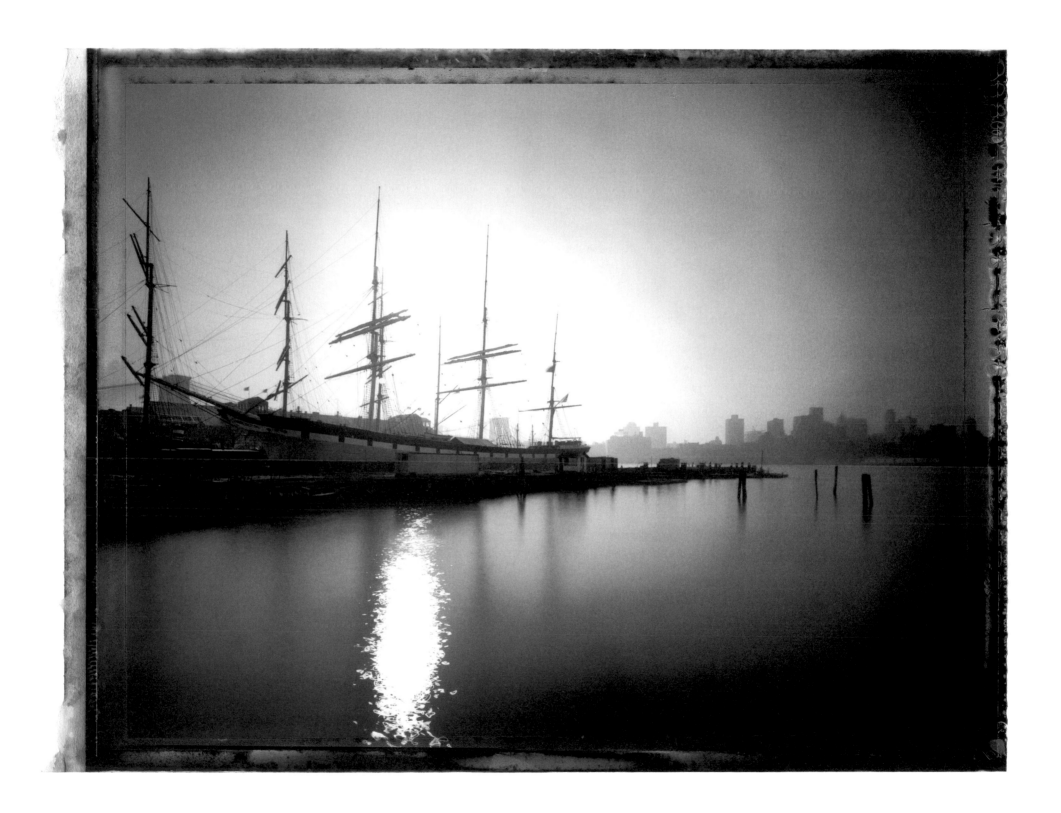

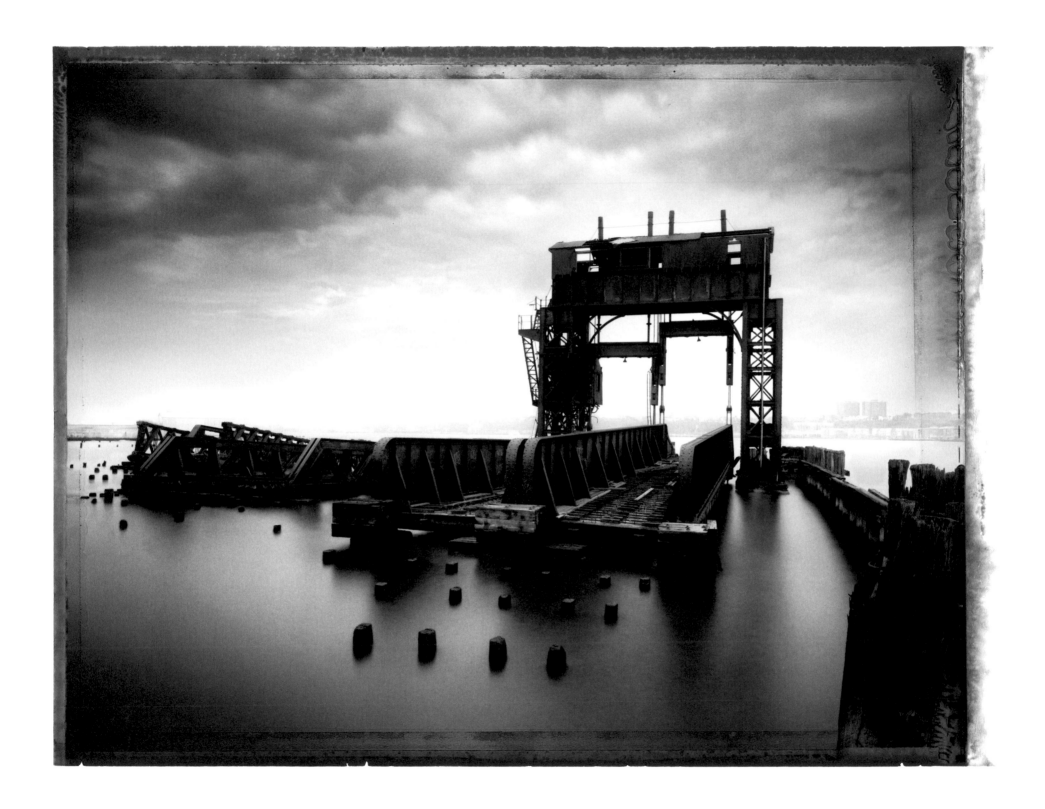

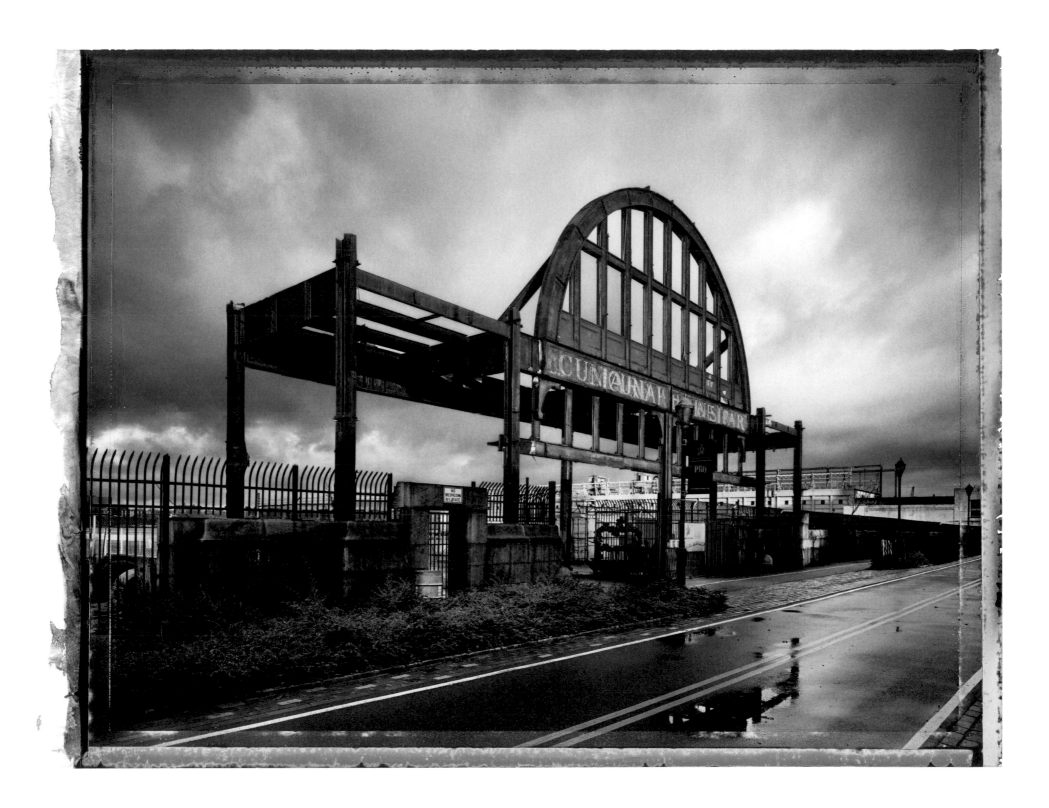

SOUTH FERRY TERMINAL

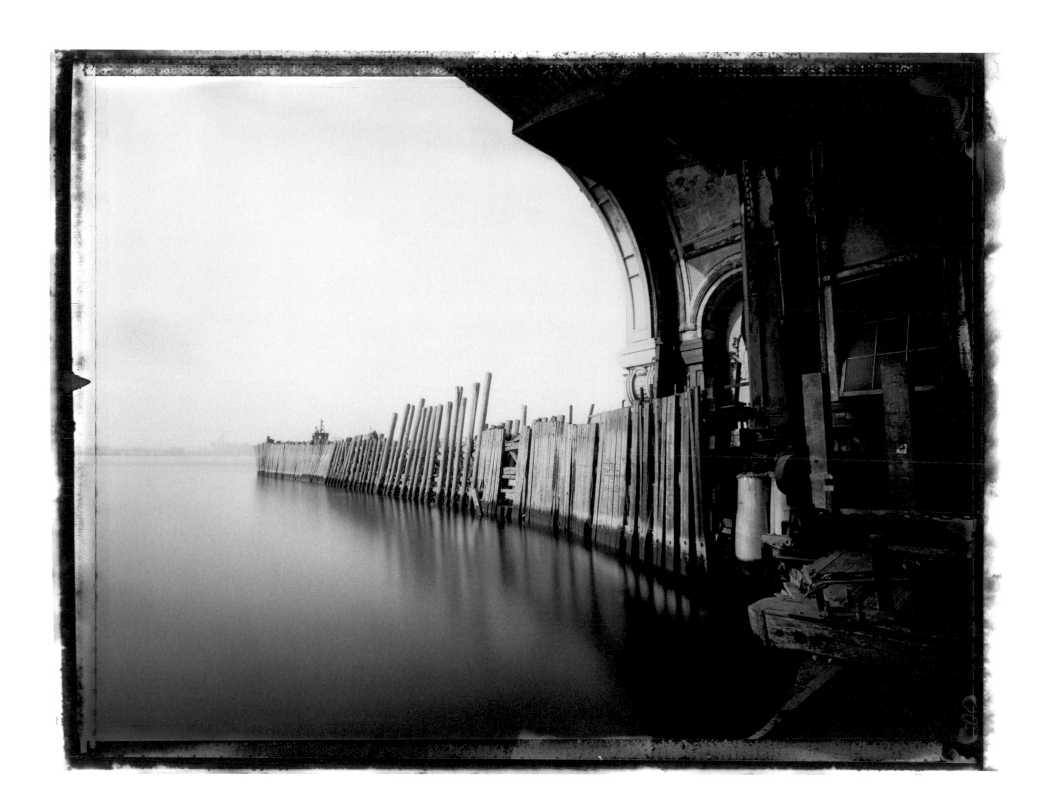

VIEW FROM WEEHAWKEN

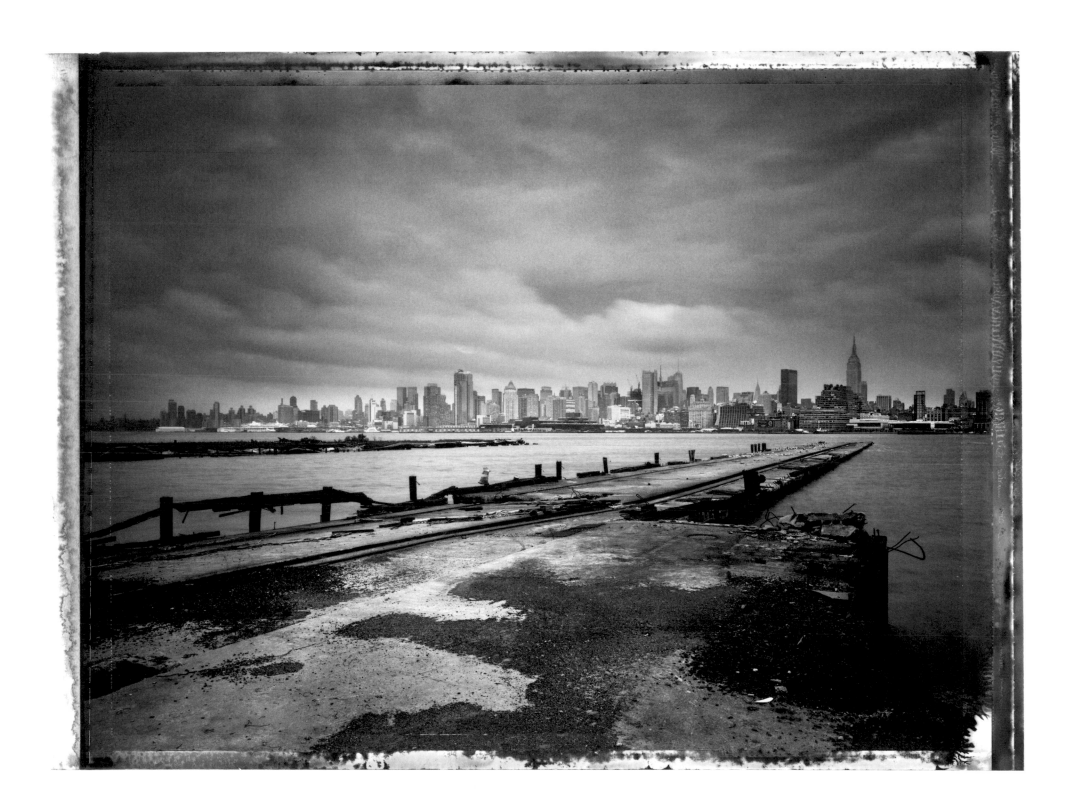

PIER AT RIVERSIDE PARK II

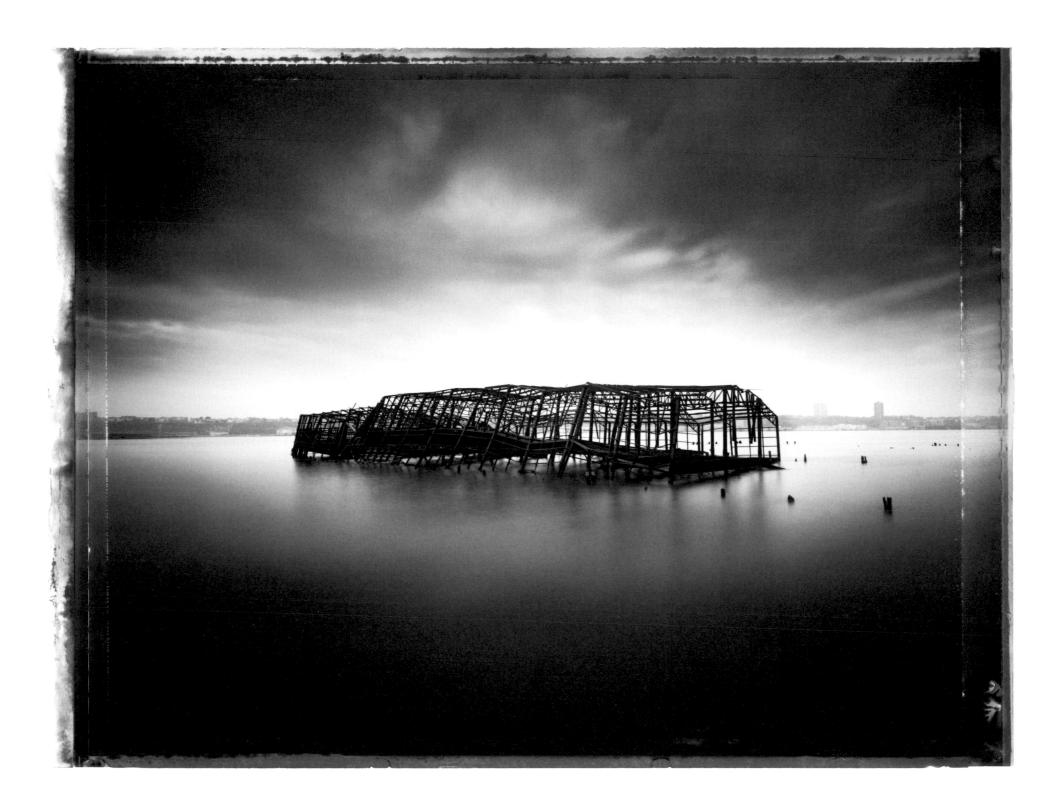

IV

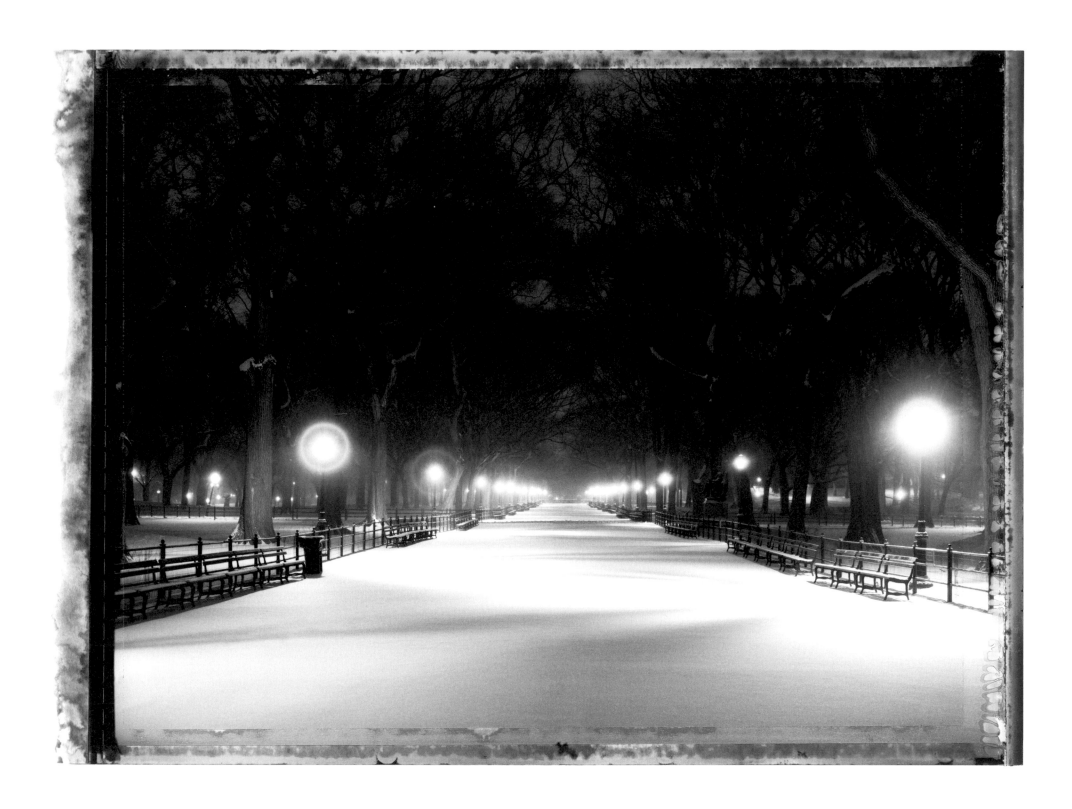

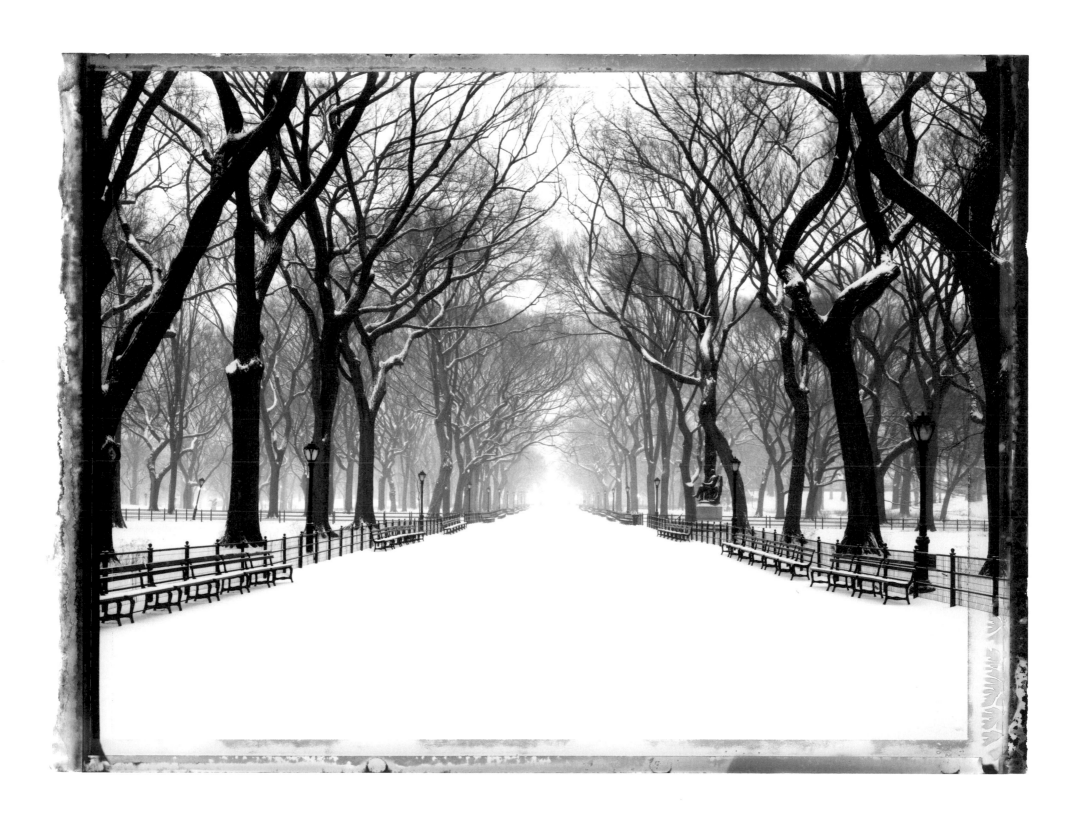

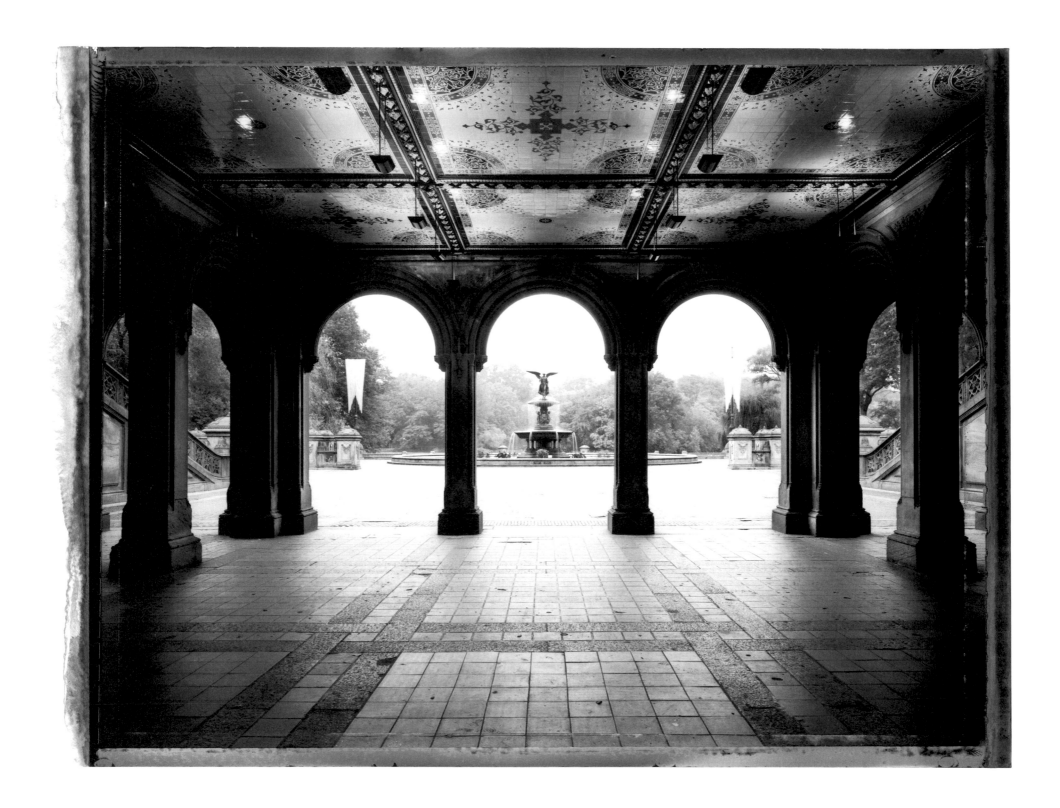

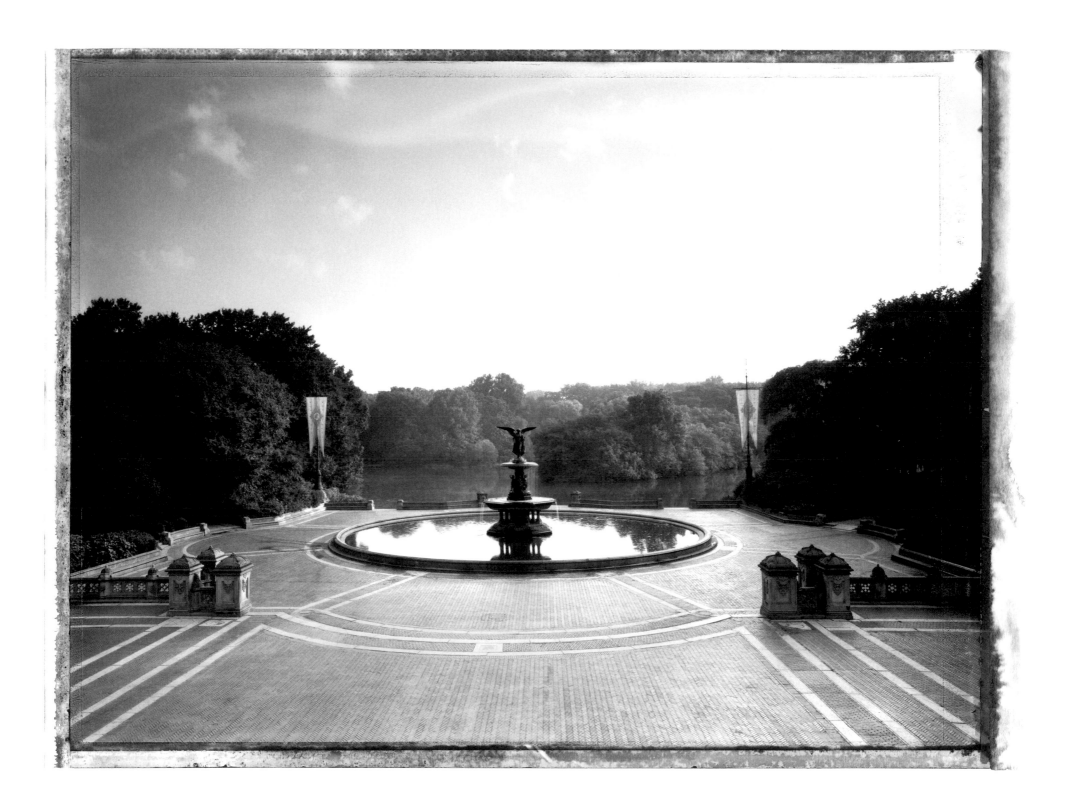

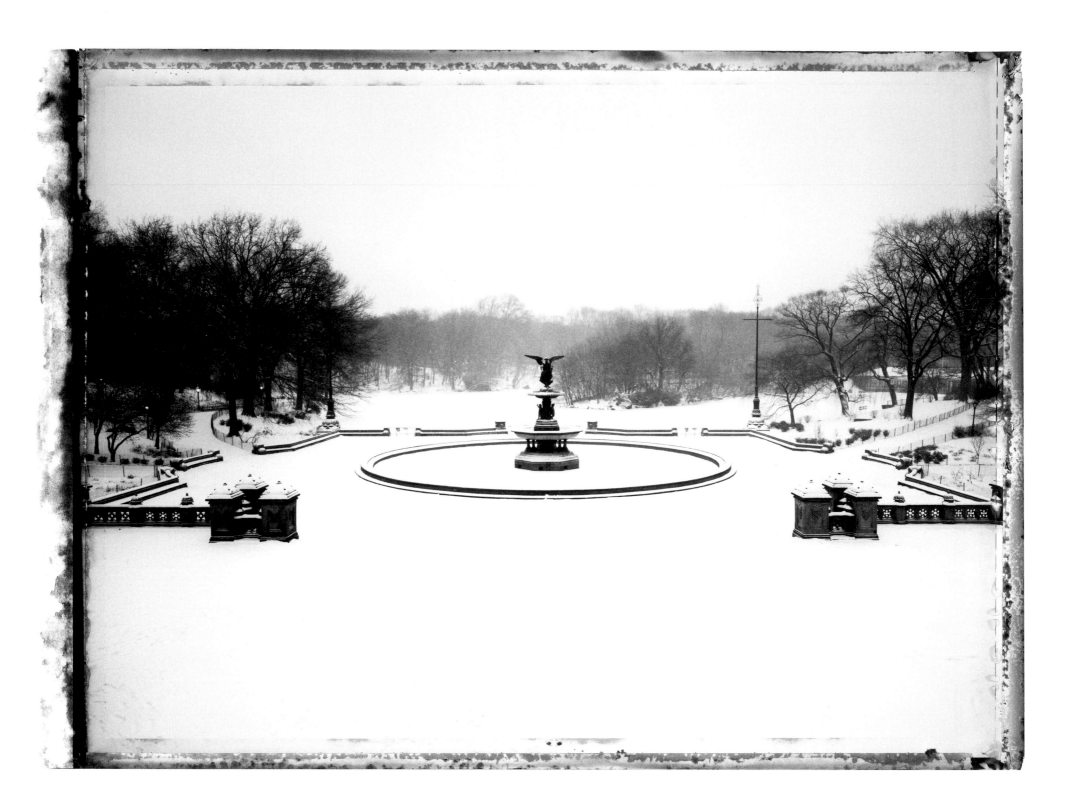

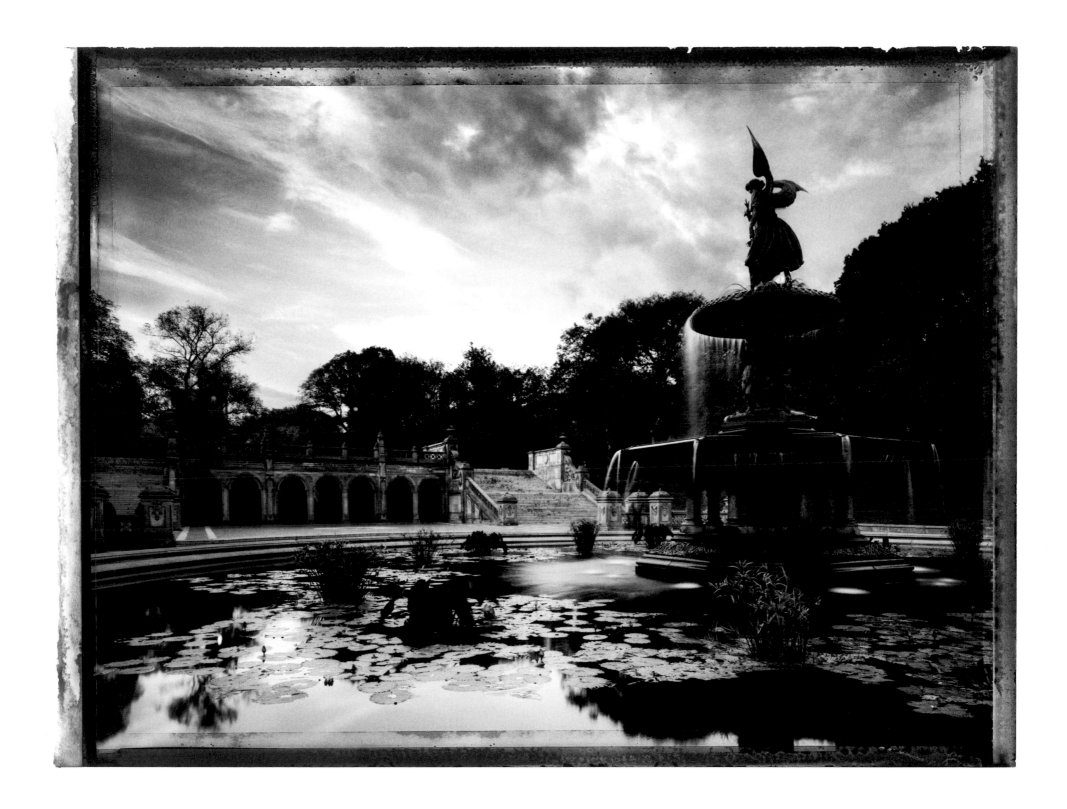

CENTRAL PARK, BELVEDERE CASTLE

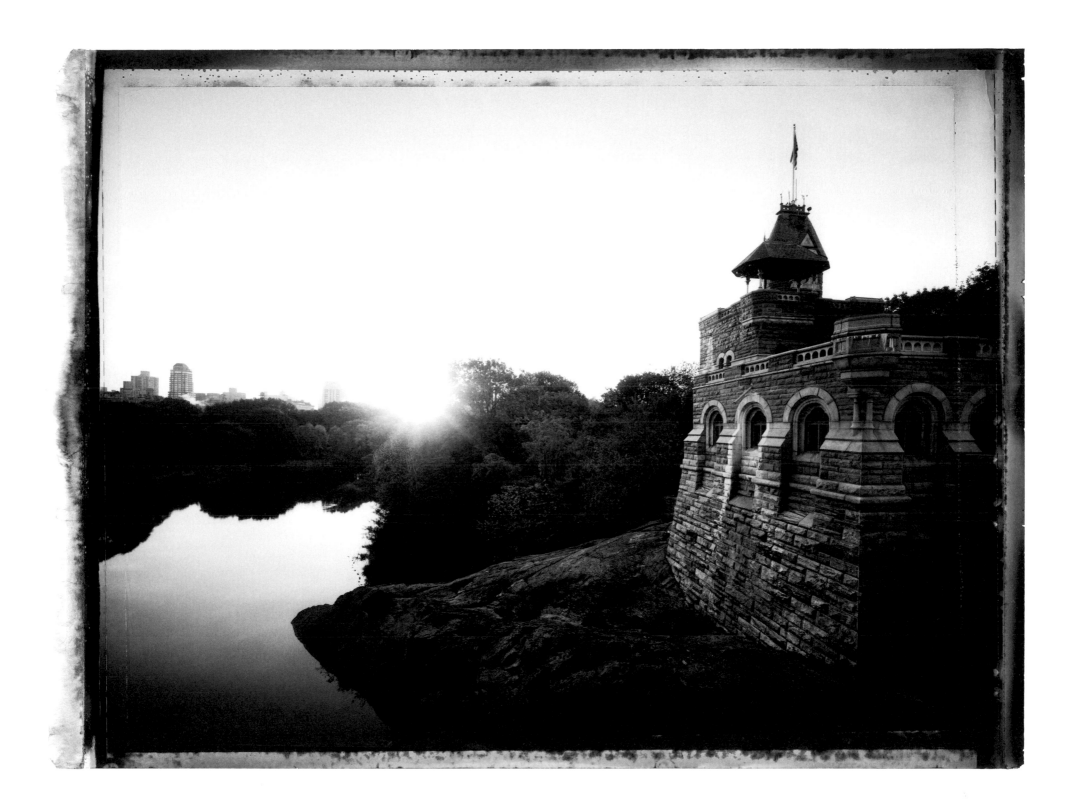

CENTRAL PARK, BOW BRIDGE

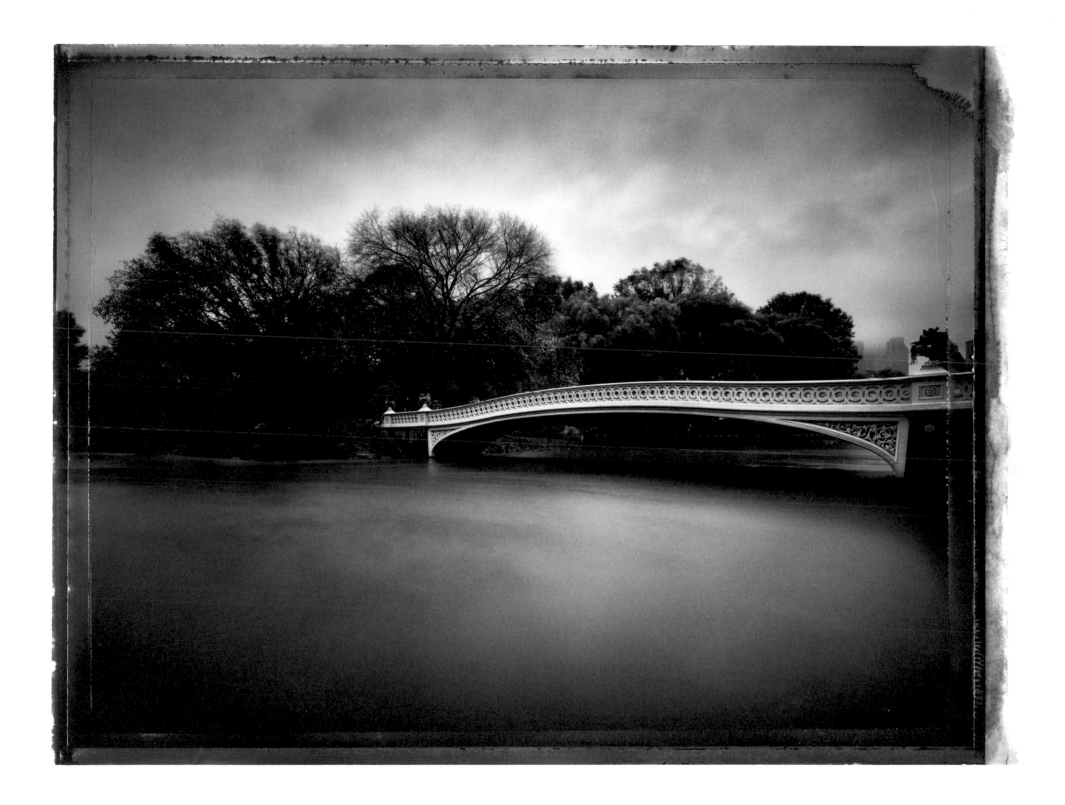

CENTRAL PARK, LADIES PAVILION

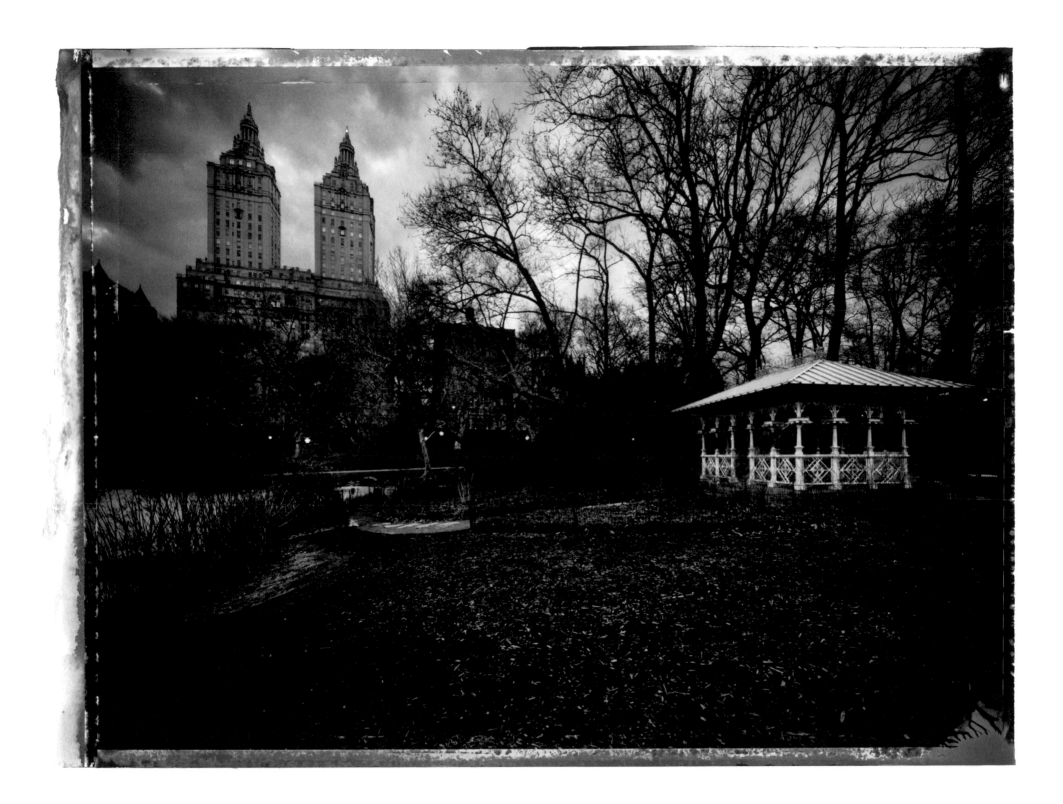

CITY HALL PARK

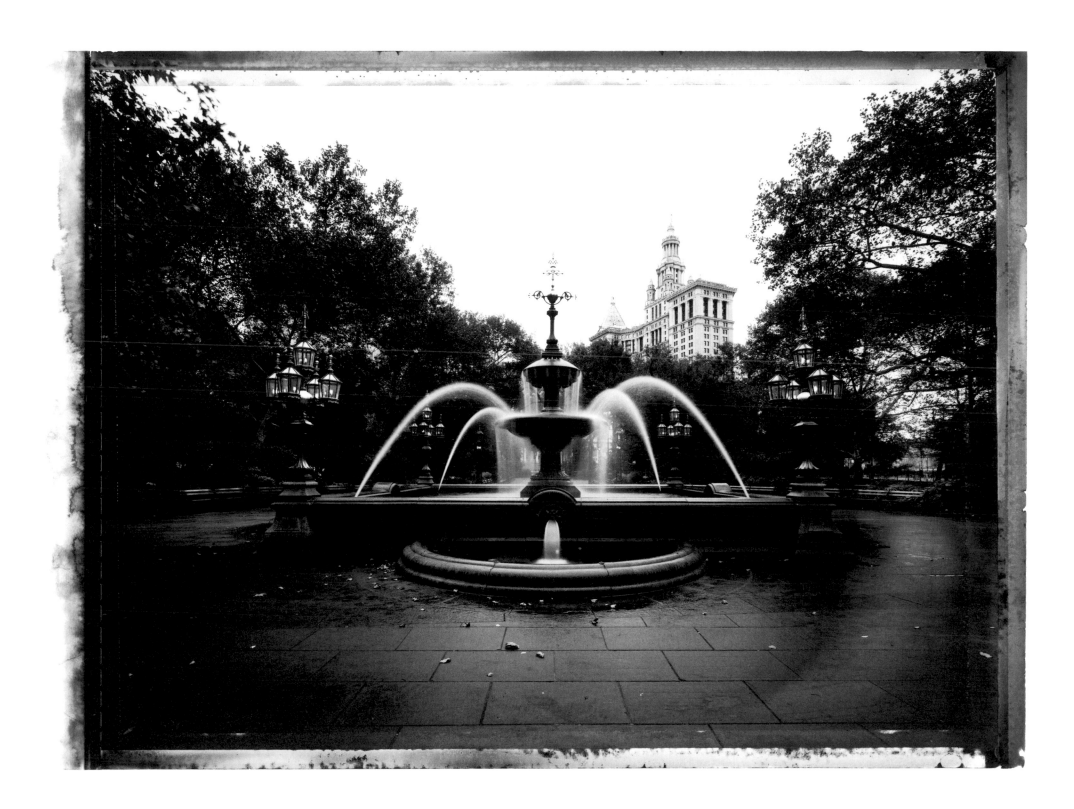

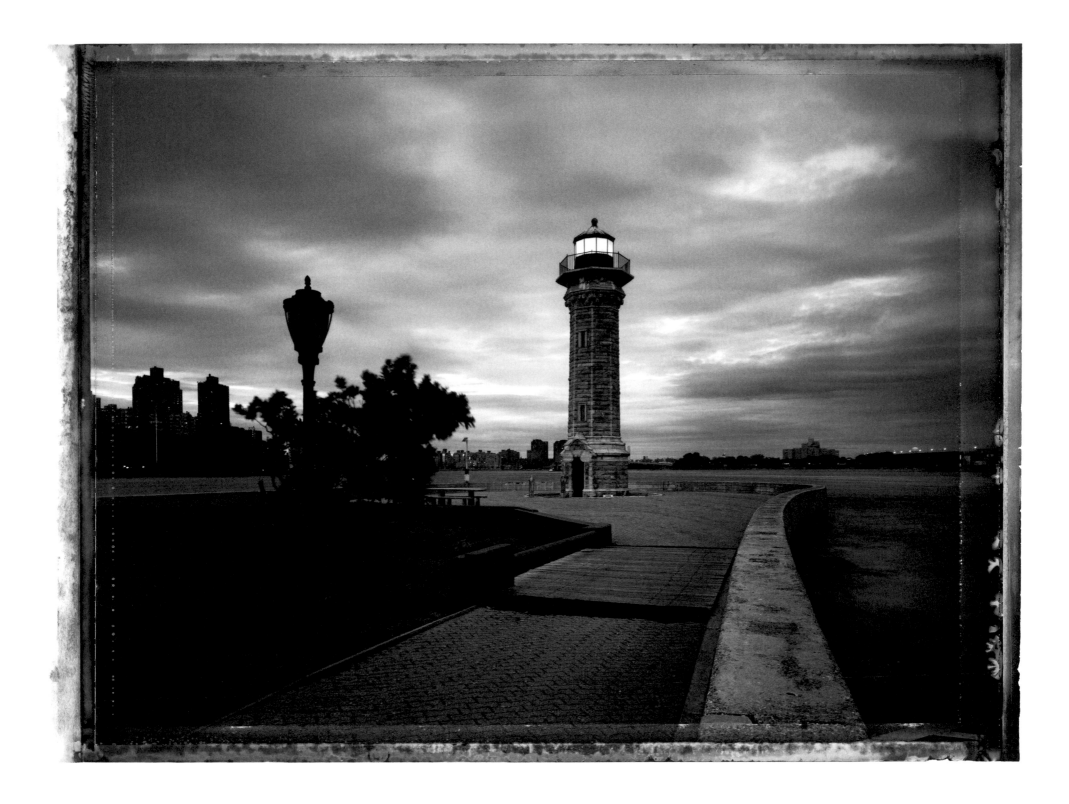

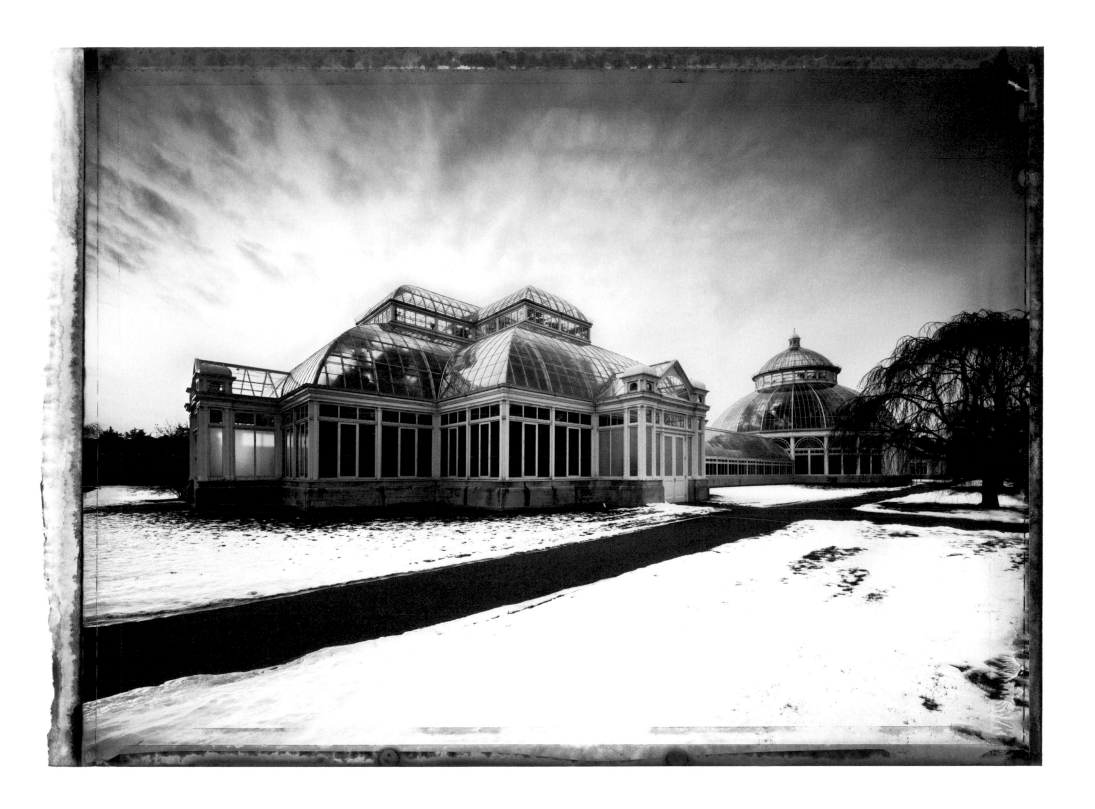

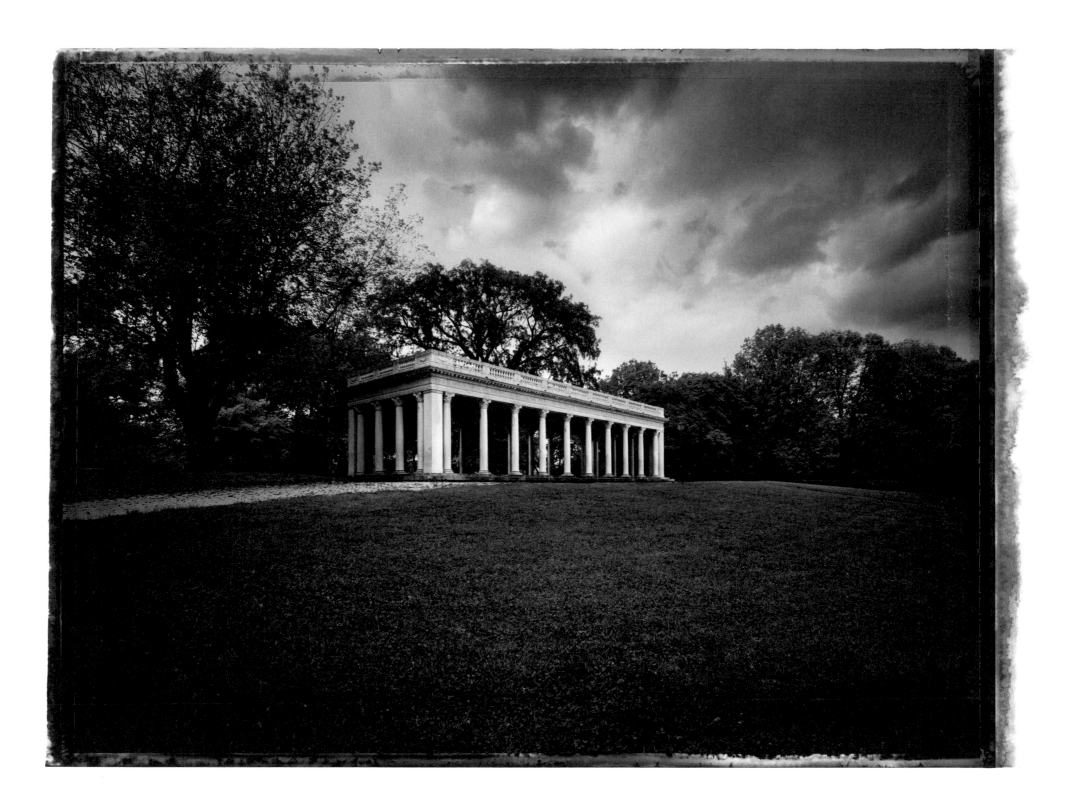

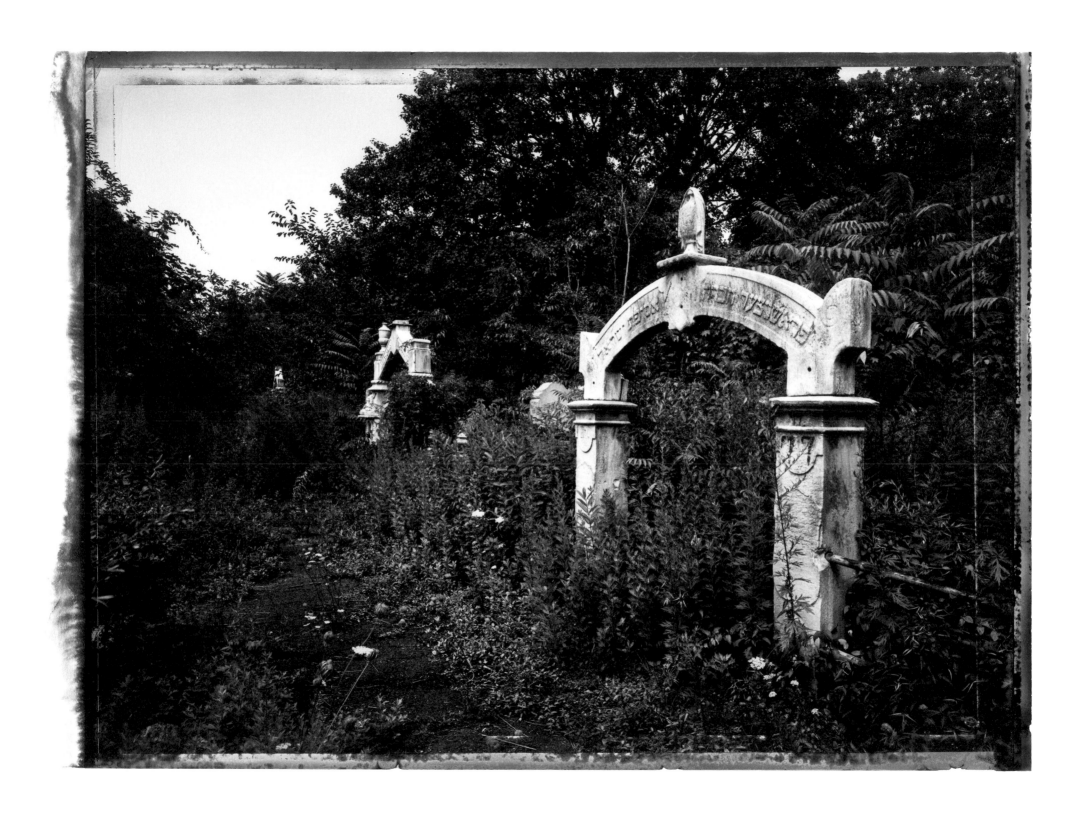

V

KATZ'S DELI

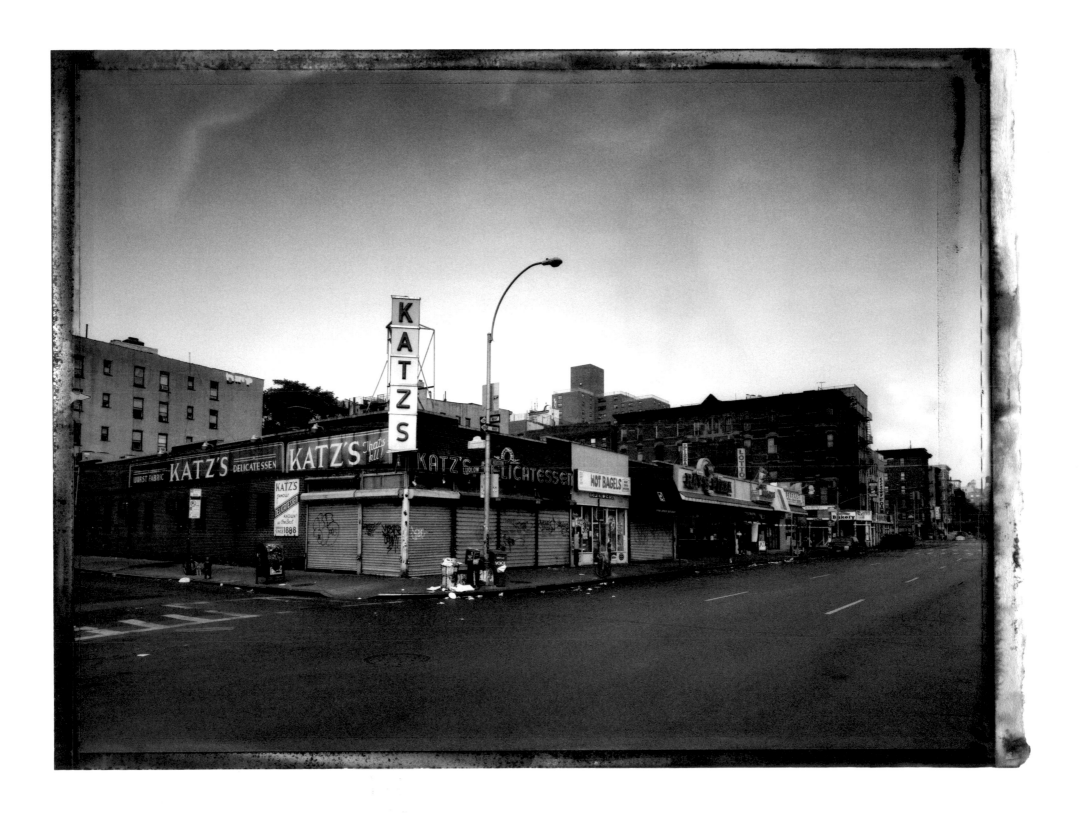

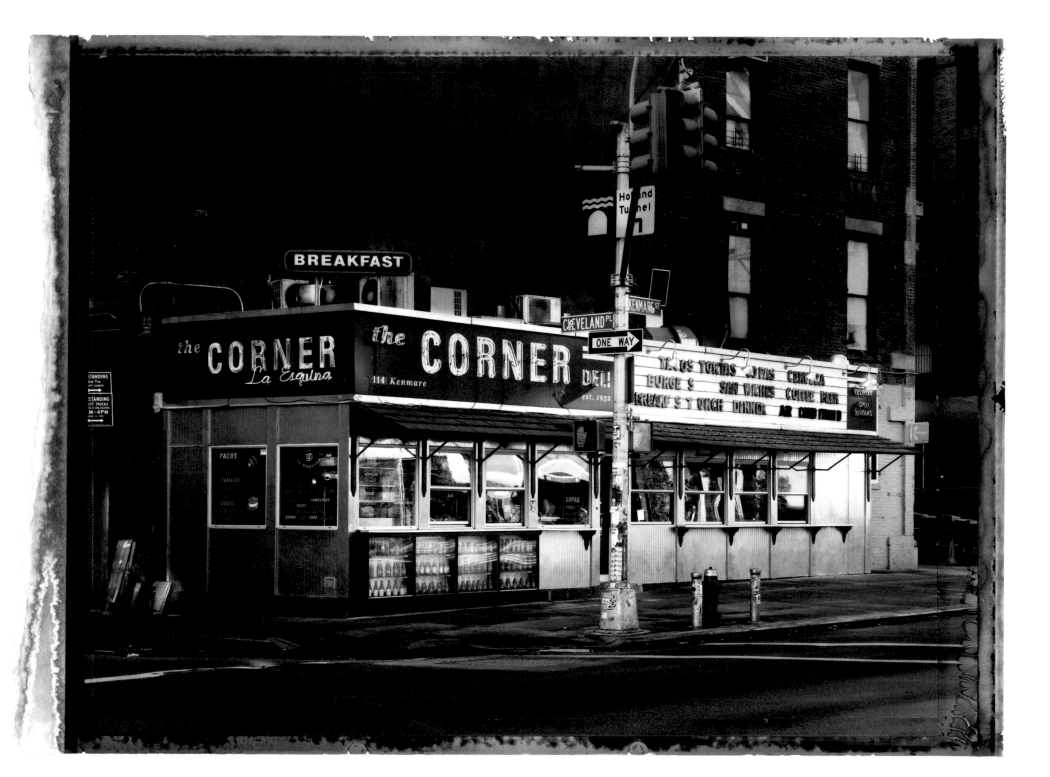

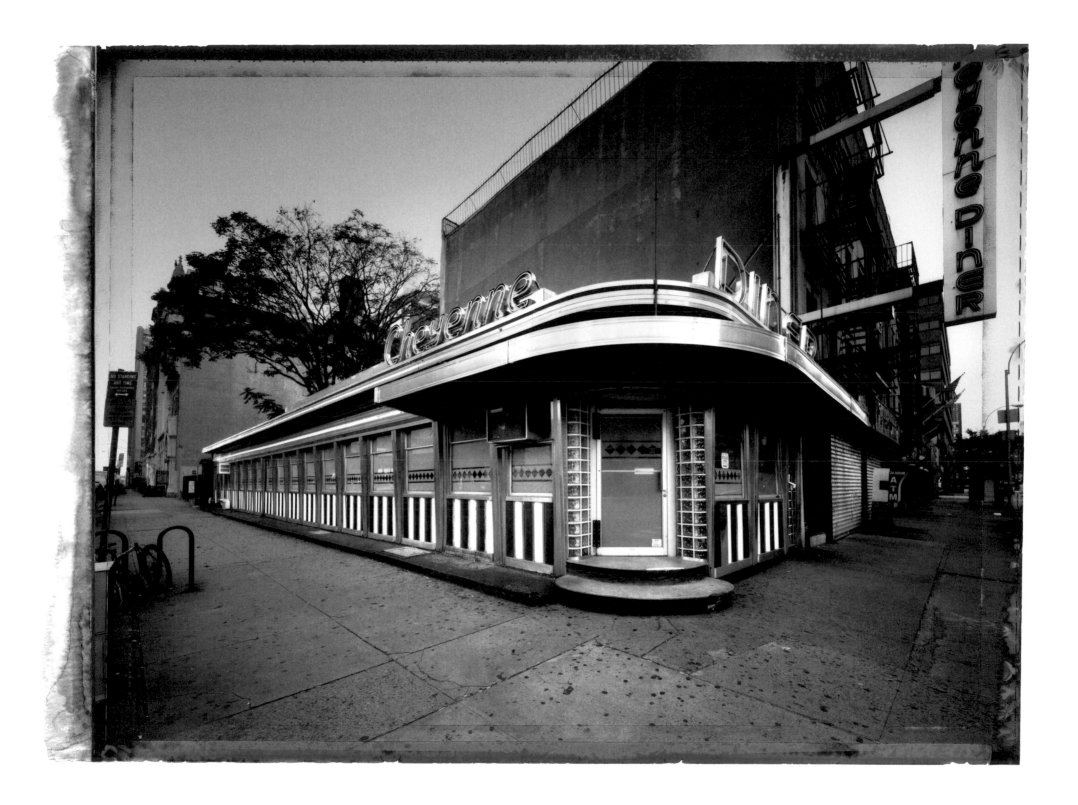

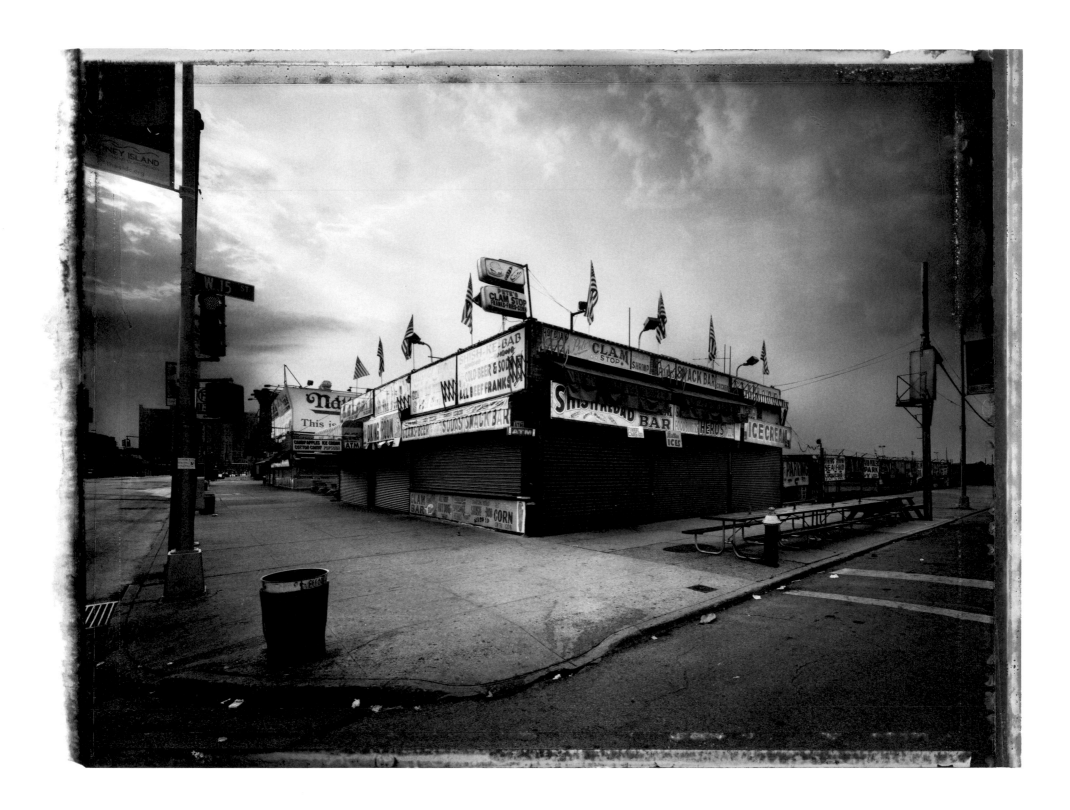

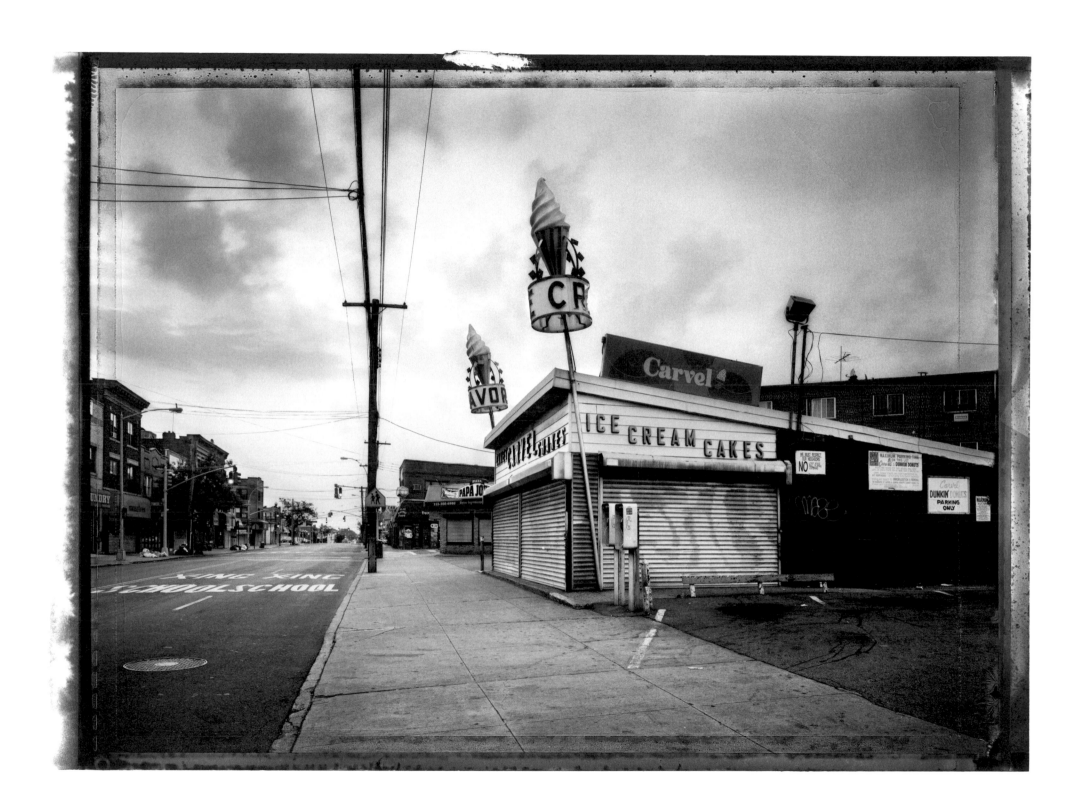

PREVIOUS SPREADS:

HOBOKEN TERMINAL II

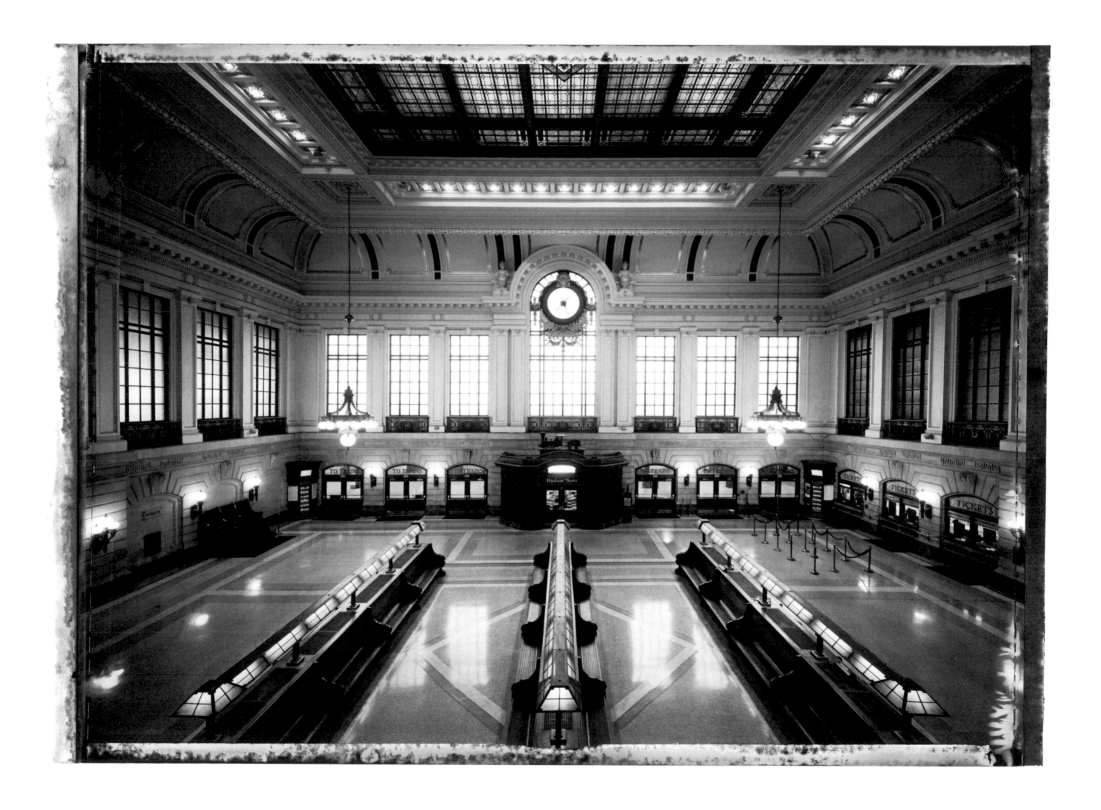

GRAND ARMY PLAZA

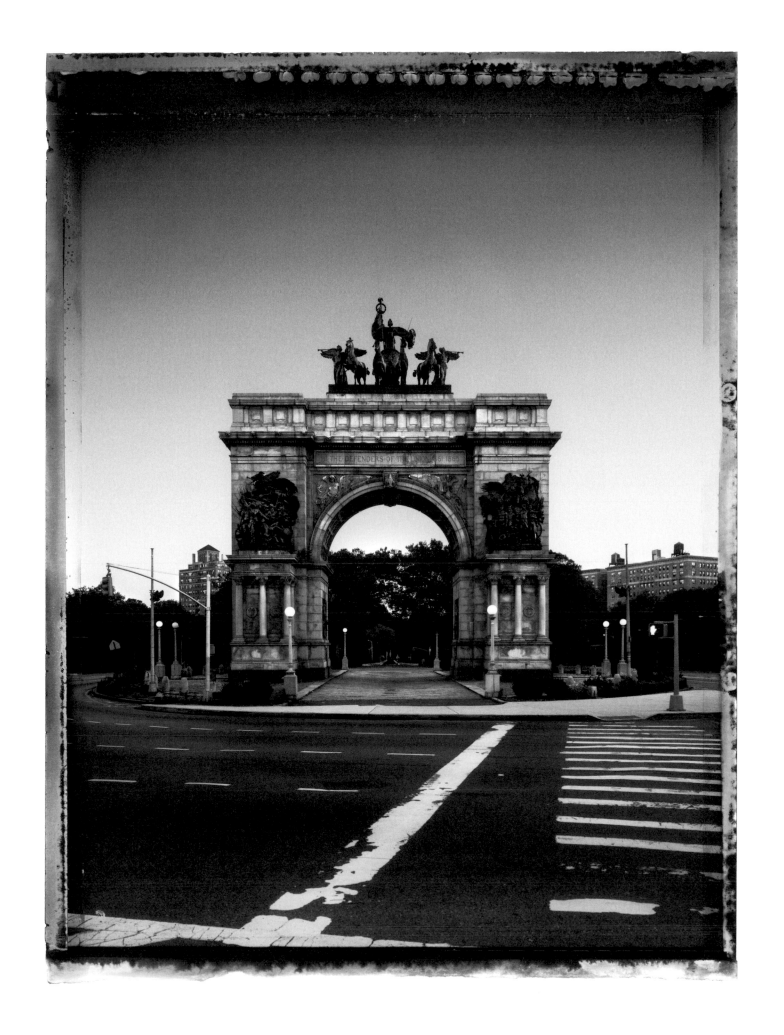

ELLIS ISLAND

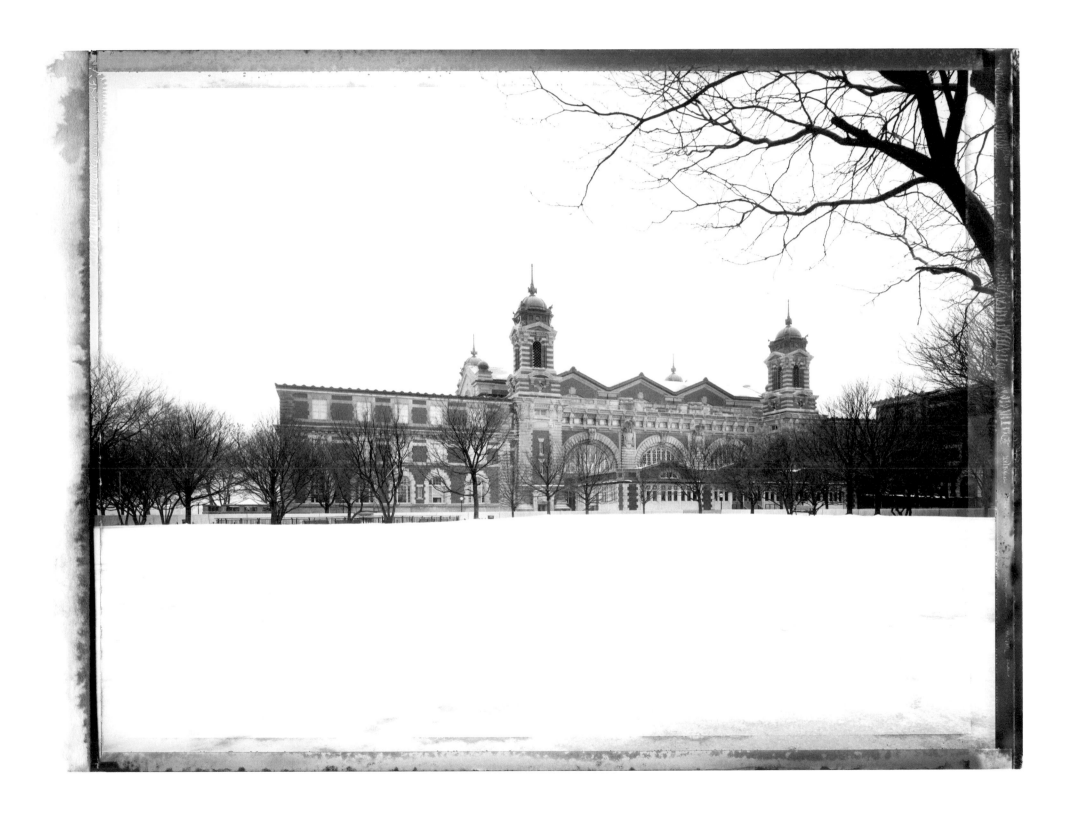

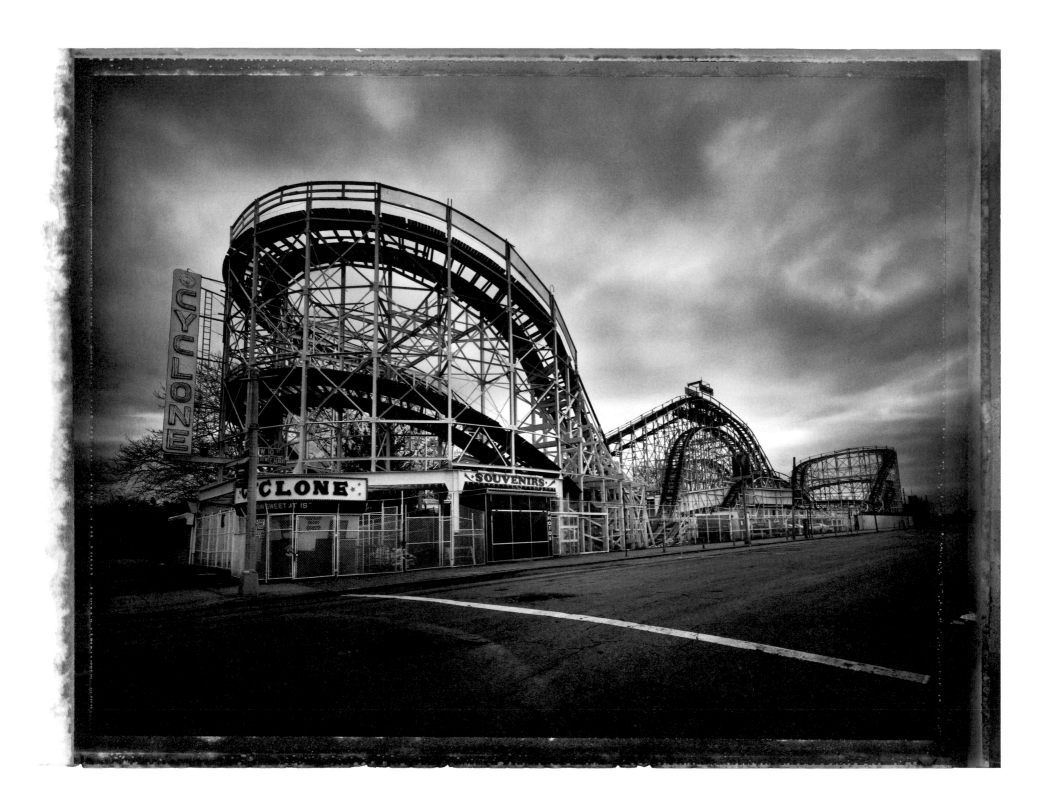

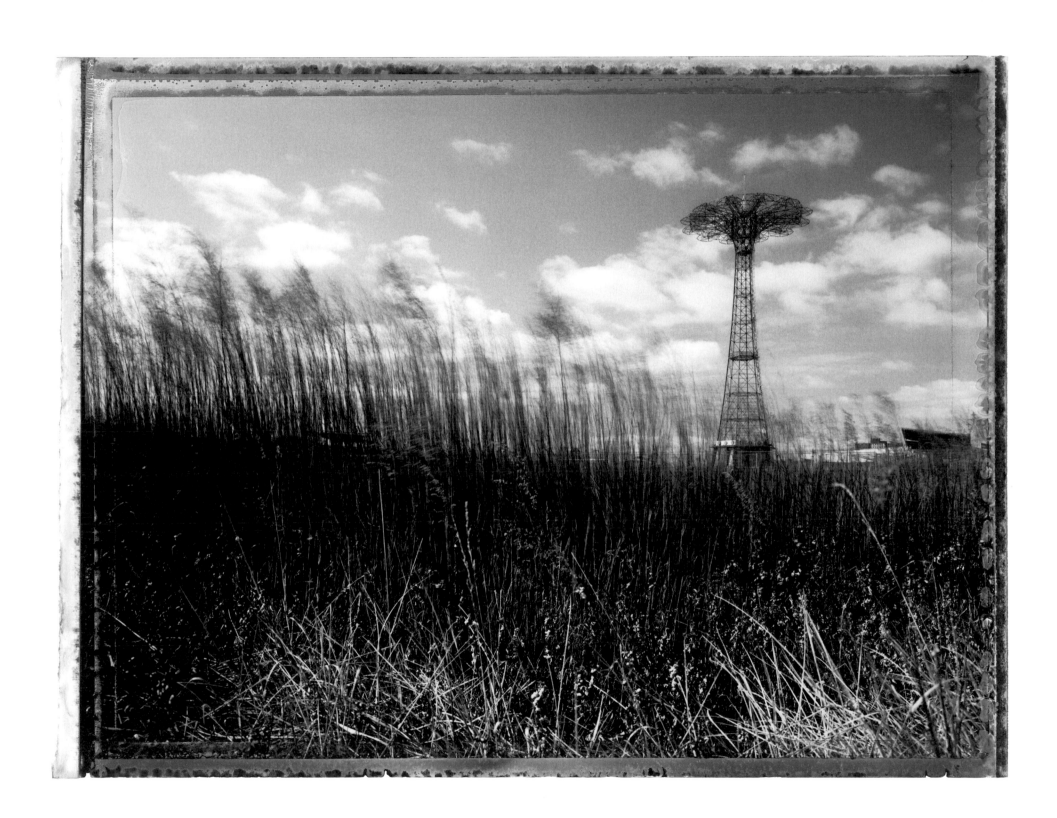

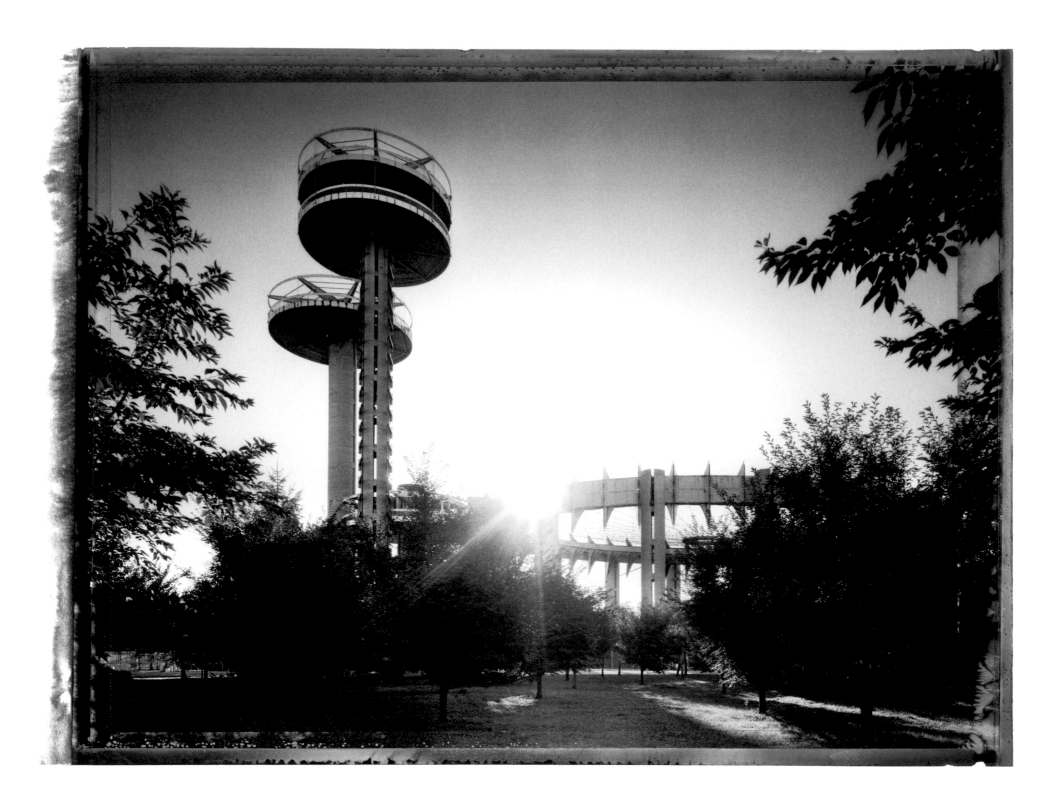

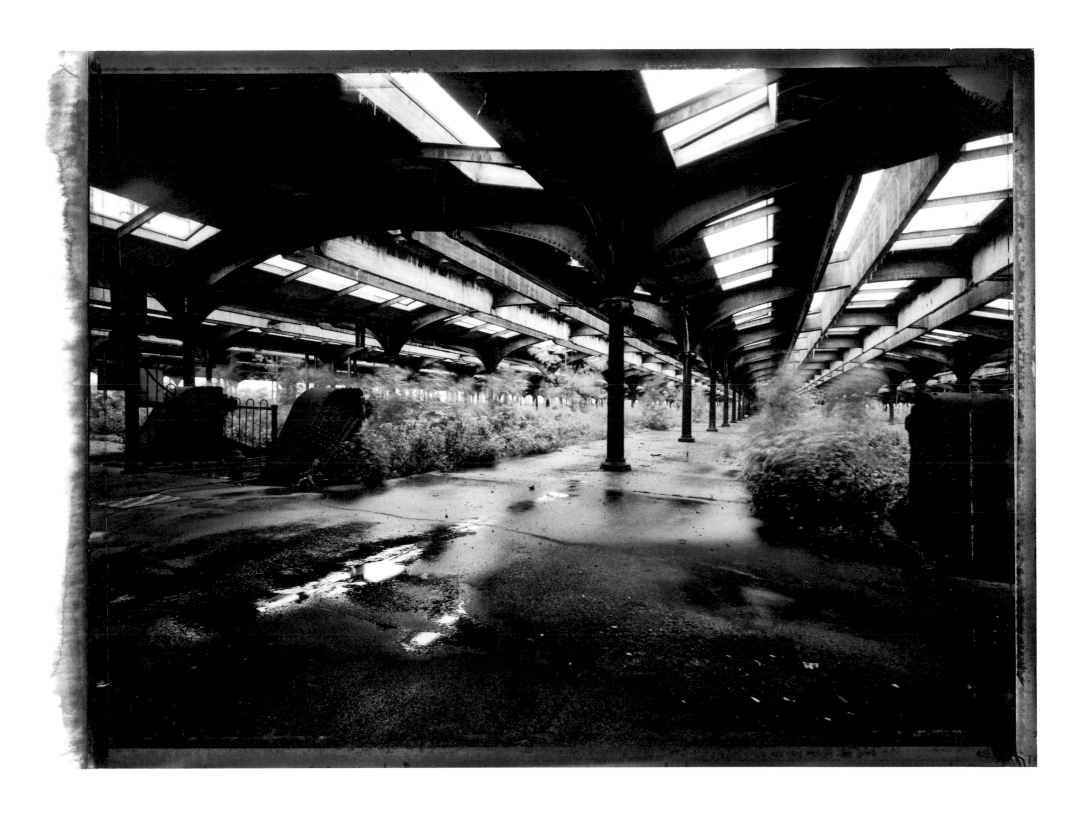

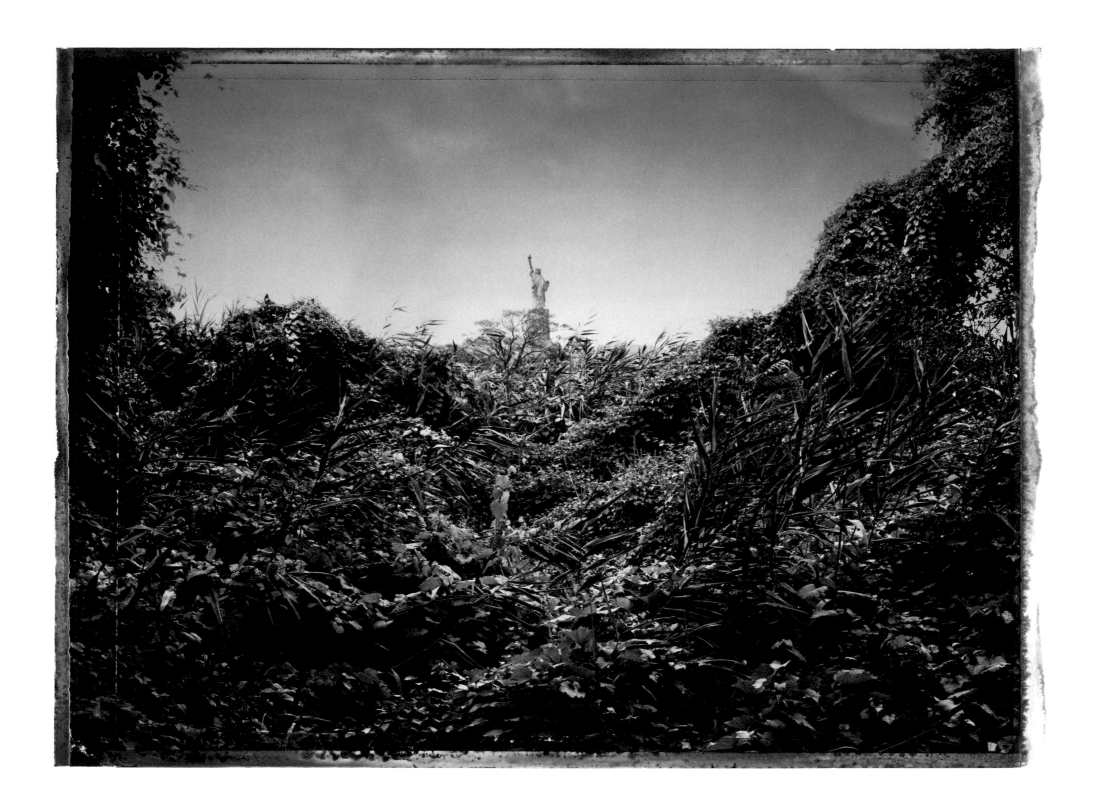

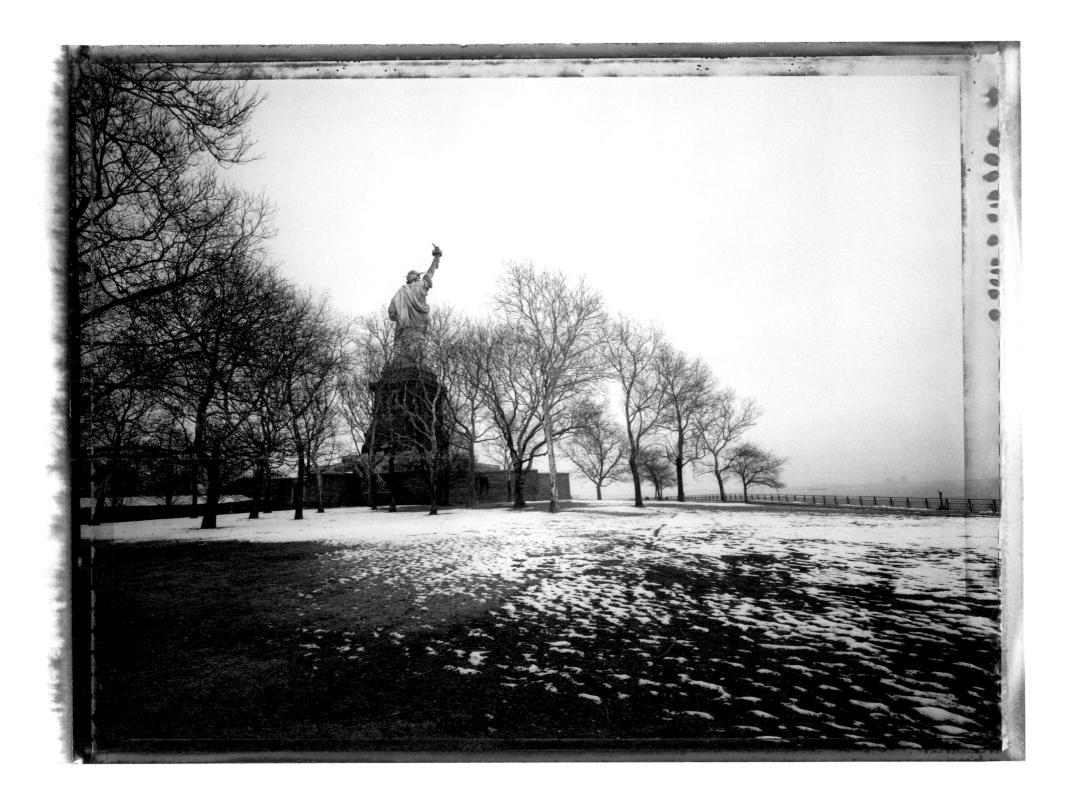

ROCKAWAY II

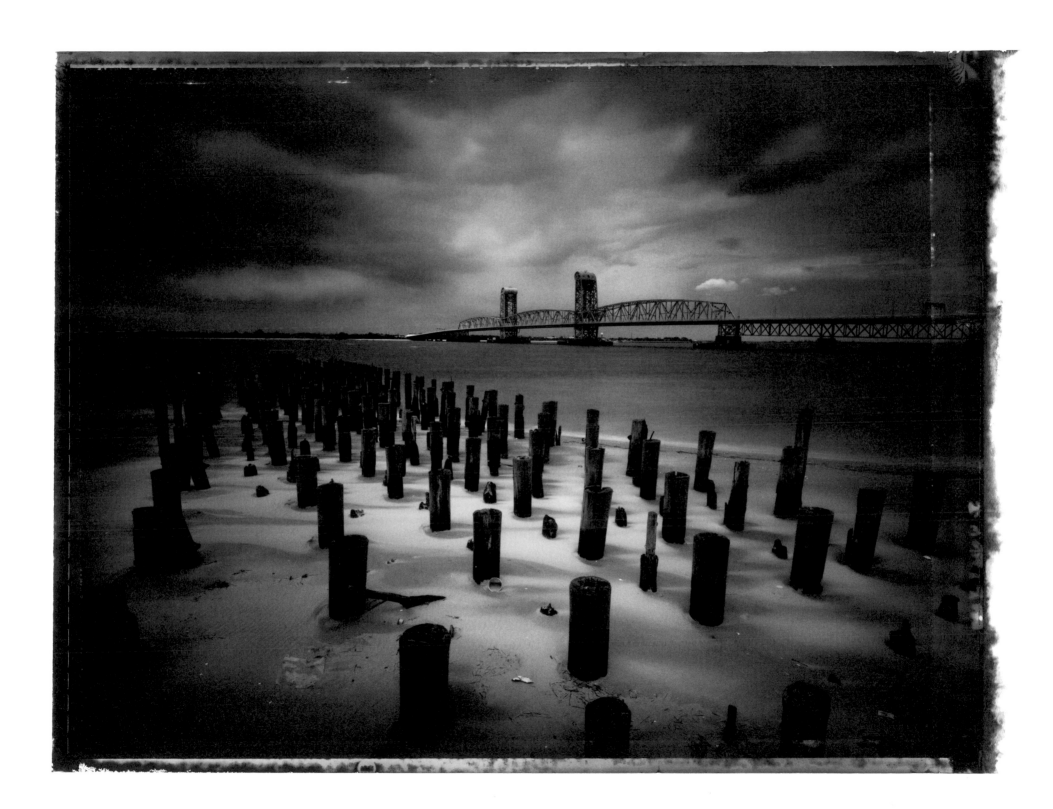

ROCKAWAY I

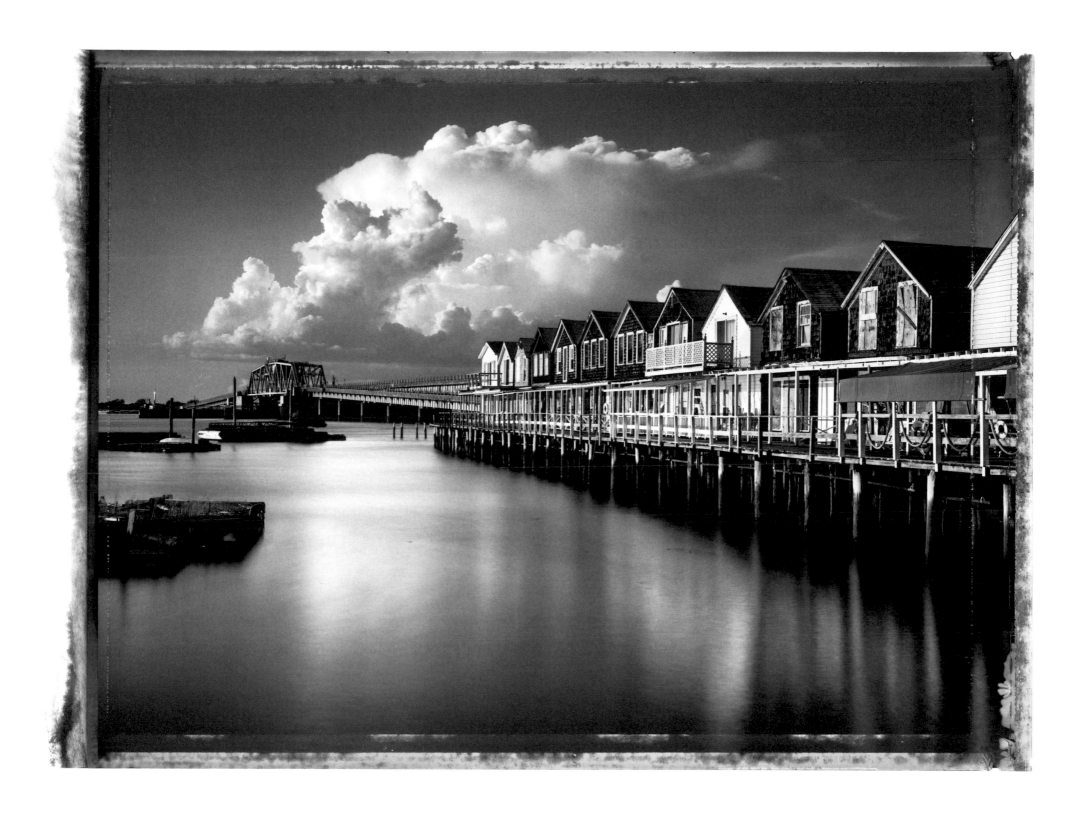

COLGATE CLOCK

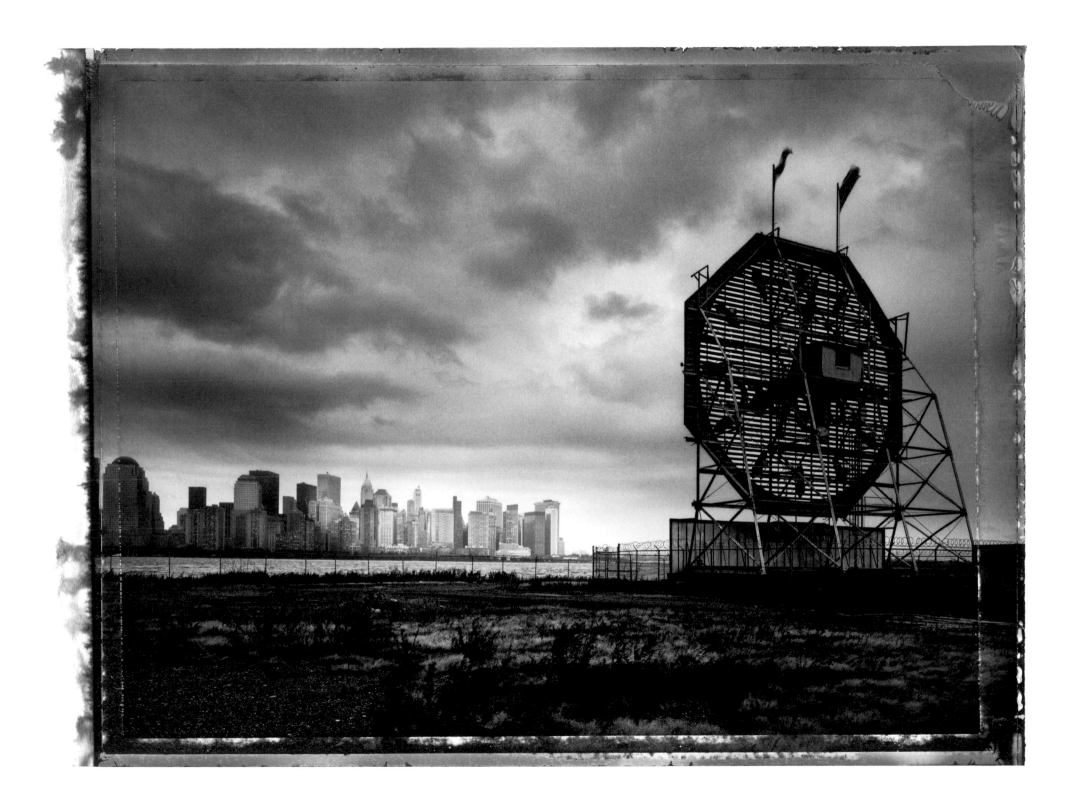

VIEW FROM ROCKEFELLER CENTER

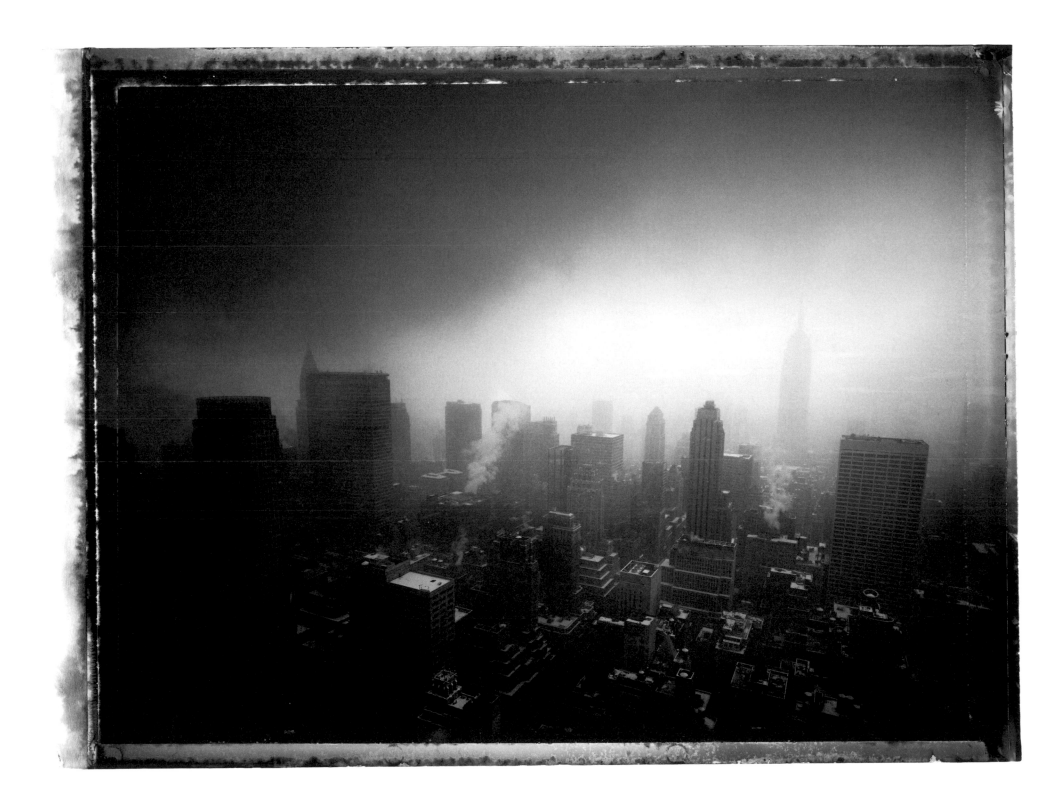

The original photographs are pigment fine art prints on Arches Cold Pressed Rag Paper in two formats: 22 x 30 in. (56 x 76 cm) in an edition of 25, and 40 x 56 in. (101,6 x 142,2 cm) in an edition of 7. Shot with Linhof Technika 4/5' on Polaroid 55.

Title of works with page numbers

Frontispiece: Flatiron Building, 2001

PETRA GILOY-HIRTZ

Associate professor and reader of medieval literature at the University of Düsseldorf for ten years. Since 1993 freelance curator, author, and editor. Numerous single-artist and thematic exhibitions at the Diözesanmuseum of the Archdiocese of Munich and Freising (1998 – 2005) among other venues, including Kiki Smith, Olafur Eliasson, Lawrence Carroll, Kai Althoff, and Mark Harrington, as well as many others. Project manager for the head of cultural affairs of the City of Munich (1998 – 2000). Recent publications include *Lucas Reiner · Los Angeles Trees,* Prestel, 2008. Currently preparing a monograph on Julian Schnabel.

IRA STEHMANN

Photography expert; curator of a Swiss photography collection. 2001 founding partner of curators, Munich. After working at an auction house, founded own company in 1993 focussing on corporate art consultancy, the creation of private and institutional contemporary art collections, the concept and organisation of exhibitions on international photographers, and the sale of contemporary art. Studied art history in London and Munich, business administration at the European Business School in Oestrich-Winkel, London, and Paris, with semesters in Italy.

ULRICH POHLMANN

Since 1991, Director of the Fotomuseum München (now the Sammlung Fotografie) as part of Munich's municipal museum. Curator of numerous single-artist and thematic exhibitions on photography and editor and author of international publications on the history of photography and contemporary art, including most recently *Voir l'Italie et mourir* (See Italy and Die) at the Musée d'Orsay in Paris in 2009, and *Nude Visions: 150 Jahre Körperbilder in der Fotografie* (150 Years of Pictures of the Body in Photography) at the Münchner Stadtmuseum in 2009.

BOB SHAMIS

Independent curator, consultant, and photographer. Author of *Leon Levinstein: The Moment of Exposure.* From 1998 to 2006 Curator of Prints and Photographs at the Museum of the City of New York and organizer of numerous exhibitions, including "New York Now 2000: Contemporary Work in Photography," "Magnum's New Yorkers," "Subway: Photographs by Bruce Davidson," and "The Destruction of Lower Manhattan: Photographs by Danny Lyon." His own photographs can be found in several permanent collections, including the Bibliotheque Nationale, Paris; the Brooklyn Museum; the Museum Ludwig, Cologne; the Museum of Fine Arts, Houston; and the San Francisco Museum of Modern Art.

Photo: Christoph Adler

CHRISTOPHER THOMAS

Born in Munich in 1961, Thomas has received many international awards for commercial photography. He has worked for magazines such as Geo, Stern, Merian, and the Süddeutsche Zeitung Magazin and produced numerous photo essays. He became known as an artist for his "Münchner Elegien" (Munich Elegies), exhibited in 2005 at the Fotomuseum München (with a publication by Schirmer/Mosel, Munich, 2005). "New York Sleeps" is to be shown in fall 2009 at the Steven Kasher Gallery in New York and at Bernheimer Fine Art Photography in Munich. Christopher Thomas lives and works in Munich.

ACKNOWLEDGEMENTS

Ira Stehmann . Petra Giloy-Hirtz

Josef Schaaf

Monika Ribbe . Christoph Adler . Elke Adam . Tobias Winkler .
Dagmar Staudenmaier . Tilman von Mengershausen

Peter Poby . Rainer Hofmann

Ulrich Pohlmann . Bob Shamis

Nicola Erni

Blanca Bernheimer . Steven Kasher

Jürgen Krieger . Thomas Zuhr . Gabriele Ebbecke . Cilly Klotz .

Victoria Salley . Christine Groß

Christine Schweikl . Dominik Thomas . Joachim Grüninger .

John Kalish . Cynthia Kayan

Nina, Lucy, and Ella Thomas

Front cover: Brooklyn Bridge II, 2001
Frontispiece: Flatiron Building, 2001

Prestel Verlag
Königinstrasse 9
80539 Munich
Tel. +49 (0)89 24 29 08-300
Fax +49 (0)89 24 29 08-335
www.prestel.de

Prestel Publishing Ltd.
4 Bloomsbury Place
London WC1A 2QA
Tel. +44 (0)20 7323-5004
Fax +44 (0)20 7636-8004

Prestel Publishing
900 Broadway, Suite 603
New York, NY 10003
Tel. +1 (212) 995-2720
Fax +1 (212) 995-2733
www.prestel.com

Library of Congress Control Number is available; British Library Cataloguing-in-Publication Data: a catalogue
record for this book is available from the British Library; Deutsche Nationalbibliothek holds a record of this publi-
cation in the Deutsche Nationalbibliografie; detailed bibliographical data can be found under: http://dnb.ddb.de

Prestel books are available worldwide. Please contact your nearest bookseller or one of the above addresses
for information concerning your local distributor.

Editorial direction: Gabriele Ebbecke

Translated from the German by Steven Lindberg, Berlin
Copyediting: Christopher Wynne, Bad Tölz
Design, layout and typesetting: one pm, Petra Michel, Stuttgart
Production: Christine Groß
Origination: Reproline Genceller, Munich
Printing and binding: Passavia Druckservice GmbH, Passau

Printed in Germany on acid-free paper

ISBN 978-3-7913-4234-4